MW01075119

# ILLUMINATED MANUSCRIPTS

## TREASURES OF
## THE PIERPONT MORGAN LIBRARY
## NEW YORK

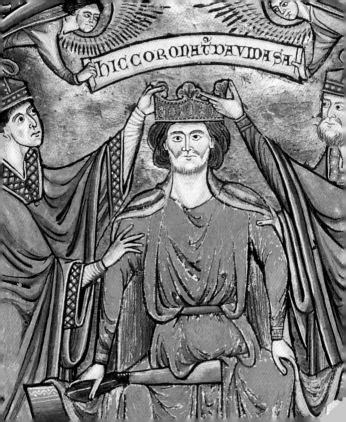

# ILLUMINATED MANUSCRIPTS

## TREASURES OF
## THE PIERPONT MORGAN LIBRARY
## NEW YORK

FOREWORD BY CHARLES E. PIERCE, JR.
TEXT BY WILLIAM M. VOELKLE
AND SUSAN L'ENGLE

A TINY FOLIO™
ABBEVILLE PRESS   PUBLISHERS
NEW YORK   LONDON   PARIS

Front Cover: Detail of Master of the Cité des Dames, *Marriage of King Philippe I and Queen Berthe*, from *Grandes chroniques de France*, c. 1410–12. See page 146.

Back cover: Detail of Master of Isabella di Chiaromonte, *Planisphere with Constellations*, from Aratus, *Phaenomena*, 1469. See page 251.

Spine: Detail of Master of B18, *Leo and Threshing*, from July calendar page, c. 1324–28. See page 258.

Frontispiece: Detail of *Coronation of David*, from *The Hachette Psalter*, c. 1225. See page 141.

Page 6: The entrance to the original Library designed by Charles McKim of McKim, Mead, and White (1902–6).

Page 8: Detail of Loyset Liédet, *Jean de Vignay Translating the Text*, from Jacobus de Voragine, *The Golden Legend*, 1460s. See page 205.

Page 15: East room of the Library. The tapestry over the fireplace represents avarice, one of the seven deadly sins.

Page 20: Detail of Master of the Berthold Sacramentary, *Journey of the Magi*, from *The Berthold Sacramentary*, c. 1215–17. See page 44.

Page 86: Detail of *Yolande de Soissons Praying*, from *The Psalter and Book of Hours of Yolande de Soissons*, c. 1280s. See page 110.

Page 136: Detail of *Saul Destroys Nahash and the Ammonites*, from *Old Testament Miniatures*, 1240s. See page 150.

Page 206: Detail of *Lions Breathe Life into Cubs*, from *The Worksop Bestiary*, before 1187. See page 219.

Page 236: Detail of Master of Petrarch's Triumphs, *Satan and the Damned in Hell*, from *The Hours of Claude Molé*, c. 1500. See page 269.

*For copyright and Cataloging-in-Publication Data, see page 287.*

# Contents

*Foreword*                                          7

*Introduction*                                      9

BIBLICAL SCENES                                    21

SAINTS, RITES, AND RITUALS                         87

ROYALTY, PASTIMES, AND PROFESSIONS               137

FLORA AND FAUNA                                   207

THE SUPERNATURAL                                  237

*Selected Bibliography*                           278

*Index*                                           281

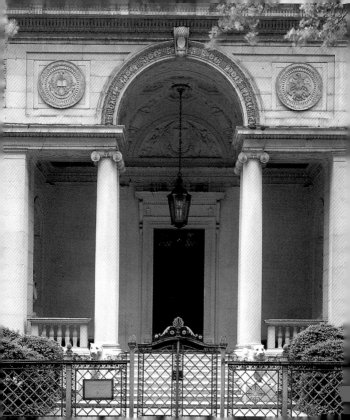

# Foreword

It is generally acknowledged that Pierpont Morgan was the greatest collector of our century. Within a period of some twenty years before his death in 1913, he assembled vast collections of antiquities, paintings, sculptures, tapestries, porcelains, watches, and other decorative objects. But none of these was to find a permanent home in The Pierpont Morgan Library. That building, commissioned from Charles McKim in 1902 and finished in 1906, was destined to house the collections that were evidently closest to his heart: autograph manuscripts, rare books and bindings, old master drawings, Mesopotamian cylinder seals, papyri, and medieval and Renaissance manuscripts. Of these, it is perhaps the last for which the Library is best known.

Pierpont's son, Jack, who founded the Morgan Library in 1924, made important additions until his death in 1943. The present volume, which includes many manuscripts acquired since 1943, conveys the full range and quality of the collection as it now exists. By making accessible to a larger audience the delights of an art form usually buried in closed books, this volume also helps fulfill the goals of the founders.

*Charles E. Pierce, Jr.*
*Director, The Pierpont Morgan Library*

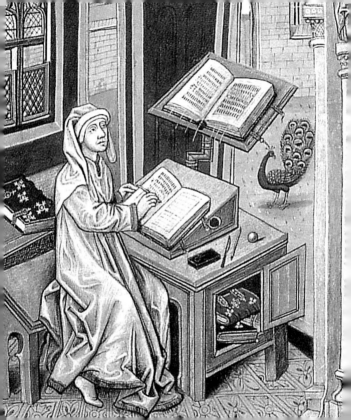

# Introduction

Medieval and Renaissance illuminated manuscripts are many-splendored things, objects of both great beauty and tremendous pictorial variety and richness. They are like museums between the covers of books and constitute the largest surviving body of painting from this period. Because the pictures have been protected by bindings, their incredible freshness has been preserved and they have avoided the vicissitudes suffered by panel and wall painting. Since the miniatures have been largely spared from the hand of the restorer, they provide the most reliable resource for the study of medieval and Renaissance color. But since they are parts of books much can also be learned about how earlier men and women lived, what they wrote, read, and thought, and how they used and contributed to knowledge. One can also observe the different ways in which books were written, decorated, and bound over the centuries. The specific subjects selected, the nature of their representations, and the size of their illustrations are also telling.

The types of books, too, speak much about the medieval citizen's personal concerns. Aside from Bibles, there are all kinds of service books, such as Sacramentaries, Missals, Lectionaries, Graduals, Breviaries, Antiphonaries, Psalters, and Books of Hours; various theological

works and commentaries; and lives of the saints and other forms of devotional literature. There are scientific manuscripts dealing with astrology, astronomy, medicine, plants, animals, and minerals; and works of a more practical nature telling when and how to plant, how to take care of horses and dogs, how to hunt and fight. There are works of historical interest, such as biographies and chronicles, and texts dealing with law, exploration, and cartography. And there are books for edification, such as works by classical authors, and works for pleasure, such as the medieval romances. The images in such manuscripts are incredibly varied, however, and have remained largely hidden and little known. Furthermore, they are also light sensitive and can only be exhibited for short periods of time. In this handy volume, however, two hundred and fifty images from one of the world's greatest collections, The Pierpont Morgan Library, have been made accessible.

Given the stature of the Morgan collection, which in quality ranks with the half-dozen or so great national libraries of the Old World, one might assume that John Pierpont Morgan was the first to collect illuminated manuscripts in America. Nothing could be further from the truth, for the earliest illuminated manuscript recorded in America was the early fifteenth-century *Speculum humanae salvationis* (Mirror of Human Salvation), which Elihu Yale gave in 1714 to the college that

bears his name. Nor was Morgan the first to collect medieval manuscripts in New York, for the Union Theological Seminary had acquired thirty-seven manuscripts from Professor Leander van Ess in 1838. And, in November 1884, shortly after it was founded, the Grolier Club held what was probably the first exhibition of illuminated manuscripts in America. Eight years later a larger exhibition was held, this time with a catalog, indicating the rising number of collectors. These collectors included Robert Hoe and Henry Walters, the latter having acquired his first manuscript (a Book of Hours) by 1895, when he both became a member of the Grolier Club and received his inheritance.

Morgan, however, was not yet among these, for he did not start collecting on a large scale until after his father's death in 1890, when he acquired the means to do so. Even then, he did not become a member of the Grolier Club until 1897. And his first documented manuscript with full-page miniatures was not medieval at all, but an early nineteenth-century *Ragamala* (M.211) made in Jaipur. It came with the purchase of James Toovey's collection of bindings and books on June 2, 1899, which also included six Western manuscripts (two were fifteenth-century humanist manuscripts [M.118, M.244]; one, a seventeenth-century copy of *Les douze empereurs* [M.121], or The Twelve Caesars, did contain portrait busts). The Toovey collection, referred to by contemporaries as a

"Library of Leather and Literature," was, in fact, purchased for its bindings and early printed books. Morgan had already been inclined toward fine bindings, having tried his hand at bookbinding as a teenager. The *Ragamala* was evidently part of the Toovey collection on account of its gold embroidered silk binding.

The real cornerstone of the medieval collection, however, was laid following a cable sent on July 4, 1899, to Pierpont Morgan by his precocious book-collecting nephew, Junius Spencer Morgan. In the cable Junius informed his uncle that he could obtain for him a famous ninth-century Gospels in a jeweled binding, a treasure unequaled in France or England, for ten thousand pounds. Morgan wisely took his nephew's advice and purchased the manuscript. Known as the Lindau Gospels (after the location of the Swabian convent that once owned it on the island of Lindau on Lake Constance), it became Morgan's first major illuminated manuscript. Its number is easy to remember, for it is M.1. The manuscript was written at the Swiss Abbey of St. Gall at the end of the ninth century, but the two covers, which were added later, were made elsewhere. The front cover, made about 880 in one of the imperial workshops of Charles the Bald, is one of the finest examples of Carolingian goldsmith work, while the back cover was made about a century earlier, probably in Salzburg, Austria.

Evidently inspired by this auspicious beginning,

Morgan again took his nephew's advice and purchased, in 1900, the library of Theodore Irwin (of Oswego, New York). Among the several thousand books were sixteen manuscripts, including the *Golden Gospels of Henry VIII* (M.23) and a French Apocalypse (M.133, see pages 76–77) of about 1415 made for Jean, duc de Berry, the most famous patron of illumination in the early fifteenth century.

The most important bulk purchase, however, was made during the summer of 1902, when Morgan acquired the impressive collection of Richard Bennett of Manchester. The seven hundred volumes included thirty-two books printed by William Caxton (the first English printer) and 110 manuscripts, thirty of which had belonged to William Morris. Important English manuscripts included the late twelfth-century Worksop Bestiary (M.81, pages 218–219, and 244) and the late thirteenth-century Windmill Psalter. As before, the collection was purchased through Junius Spencer Morgan. Indeed, the important role played by Junius has not been sufficiently made known, and it is tempting to suggest that without him, Morgan might never have collected manuscripts at all, or at least not on the same scale. The Bennett collection provided Morgan with a nucleus around which to build.

Although it is often assumed that Morgan purchased everything in bulk, this is hardly the case for the manuscripts. In fact, the total number of manuscripts that

came as parts of collections was only slightly less than the 144 Ludwig manuscripts that formed the nucleus for the manuscript collection of The J. Paul Getty Museum. Normally, manuscripts were acquired singly or in small groups. The celebrated Book of Hours illuminated by Giulio Clovio for Cardinal Alessandro Farnese is a case in point (M.69, pages 24–25, 32, 55, 61, 216–217, and 277). It was offered by the Frankfurt firm of Goldschmidt in 1903, while Morgan was taking the cure at Aix-les-Bains. The manuscript had everything going for it: beauty, fame, importance, distinguished provenance, and even a binding then attributed to Cellini. Vasari, in his *Lives of the Painters*, described each of its full-page miniatures, regarding it as one of the sights of Rome. Morgan was so pleased with the manuscript that, uncharacteristically, he took it with him personally rather than have it sent.

Meanwhile, the construction of Morgan's library (1902–6) by the firm of McKim, Mead, and White had begun, and it was clear that Morgan would soon need a librarian. Here again, it was Junius who brought Belle da Costa Greene to the attention of Morgan. She had, at the time, been working in the library of Princeton University. Arriving in 1905, Greene soon became Morgan's trusted aid, playing a pivotal role in developing the collection of manuscripts. By Morgan's death in 1913 about six hundred manuscripts had been assembled, and these

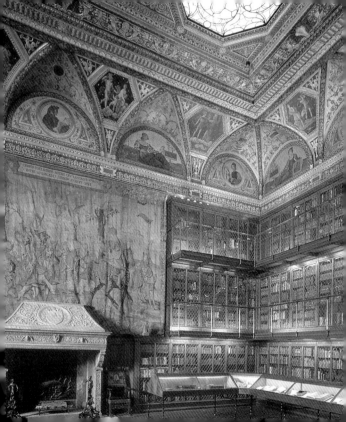

already constituted the most important collection in America. The justly famous *Da Costa Hours* (M.399, pages 54, 109, 162, 180, and 195–199), acquired in 1907, was not, as one might assume, named after Belle da Costa Greene, but after its second owner, Don Alvaro Da Costa, the armorer of King Manuel I of Portugal. It was illuminated in Bruges about 1515 by Simon Bening, the last great Flemish illuminator.

After Morgan's death, his son, J. P. (Jack) Morgan, Jr., retained Belle Greene as librarian. Although Jack had assured her that acquisitions would continue after World War I, she purchased, in 1916, and apparently on her own initiative, the Library's celebrated *Old Testament Miniatures* (M.638, pages 26–27, 136, and 150). It is also known as the Maciejowski or Shah Abbas Bible because Cardinal Bernard Maciejowski sent it to Isfahan as part of a papal mission organized by Clement VIII, which presented it to the shah in 1608. Belle Greene must have been quite relieved when she wrote to Sidney Cockerell on December 12, 1916, that the younger "Mr. Morgan was quite keen to see the manuscript and that he quite thoroughly approves of my purchasing it—which is a good omen (for me) and, I would add, for the Morgan Library." The manuscript, Jack's first major acquisition, thus provided an important turning point and represented a line of continuity, for the book had already been offered to his father in 1910. Even though Belle Greene did not realize that

the manuscript was probably made for King Louis IX, she recognized its importance and did not want to lose it a second time. One of the greatest French manuscripts of the thirteenth century, it contains in its eighty-six pages about three hundred scenes; the scale and elaboration of the Old Testament cycle, which begins with the Creation and ends with King David, is without parallel.

In 1924, Jack, realizing that the collection had become too important to remain in private hands, founded The Pierpont Morgan Library in memory of his father's love of rare books, naming Belle da Costa Greene its first director. Although Jack added only two hundred manuscripts, they were of the highest quality and importance. Whereas most of the manuscripts purchased by his father dated from the twelfth to the sixteenth century, he pushed the range back to the eighth century and added Byzantine manuscripts as well. Among the last were the Library's two finest Byzantine manuscripts: a mid-tenth-century copy of *De materia medica* of Dioscorides (M.652); and a late-eleventh-century Lectionary made in Constantinople (M.639, page 91). Significant Western additions included the earliest illustrated Beatus *Apocalypse* (M.644, pages 82–84), illuminated by Maius about 950 (1919); *The Berthold Sacramentary* (M.710, pages 44, 95, and 264), the most luxurious German manuscript of the early thirteenth century (1926); *The Psalter and Book of Hours of Yolande de Soissons*

(M.729, pages 48, 67, 110, and 175), one of the richest illustrated French manuscripts of the late thirteenth century (1927); a fragmentary Book of Hours (M.732, pages 41 and 210–211) illuminated by Jean Bourdichon (1927); and the *Life, Passion, and Miracles of St. Edmund* (M.736, pages 122 and 140) of about 1130, one of the earliest illustrated lives of an English saint (1927). It should be pointed out that even after the Library was founded in 1924, Jack continued to purchase expensive manuscripts for the Library, especially those mentioned above.

Six years after Jack's death in 1943, the Library's second director, Frederick B. Adams, Jr., founded the Association of Fellows, a group of interested supporters who made possible the continued growth of the collection, both by gifts in kind and cash. The first major manuscript acquired with the assistance of the Fellows was a Book of Hours (M.834, page 68) illuminated by Jean Fouquet (later completed by Jean Colombe), the most important fifteenth-century French painter (1950). A second important acquisition was half of the celebrated *Hours of Catherine of Cleves* (M.917, pages 50, 100–105, 190-91, and 233) a peerless Dutch Book of Hours (1963); it was made in Utrecht about 1440. The other half (M.945, pages 232, 263, and 268) was purchased (1970) under the third director, Charles Ryskamp, who also acquired in the same year the Prayer Book (M.944, page 98) painted by Michelino da Bezosso in Milan about 1420, his master-

piece. In 1983 Clara S. Peck bequeathed her richly illustrated manuscript of Gaston Phébus's *Livre de la chasse* (M.1044, pages 167, 169, 186–88, and 228–31), illuminated in Paris about 1410. But the most significant gift of manuscripts to the Library came the following year, when it received the William S. Glazier Collection of seventy-five manuscripts (for example see G.25, pages 34 and 141, and G.44, pages 42, 56, and 70), until then the most important collection in private hands. In 1985, with the death of Curt F. Bühler, for many years the Library's Keeper of Printed Books, the Library received his collection of sixty manuscripts. Two more large bequests were made under the current director, Charles E. Pierce, Jr.: the E. Clark Stillman Collection brought twenty-one manuscripts and the Julia P. Wightman Collection contained thirty-six. Thanks to the continued support of the Fellows and Friends of the Library, the collection has continued to grow, now numbering nearly thirteen hundred manuscripts.

This Tiny Folio is arranged thematically, to reflect the structure of medieval and Renaissance life and its concerns: biblical scenes; saints, rites, and rituals; royalty, pastimes, and professions; flora and fauna; and the supernatural. Although this mini-museum of pictures represents but a minuscule proportion of all that the Morgan manuscripts contain, it may serve to open the door, if slightly, to a vast world of pictorial possibility, surprise, and insight.

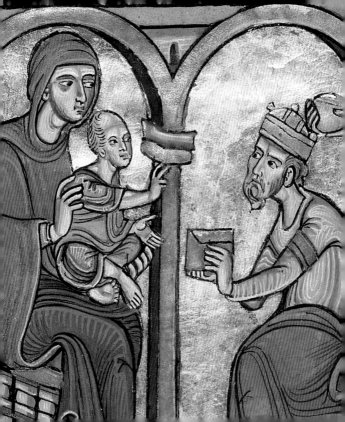

# BIBLICAL SCENES

The images painted on the pages of manuscripts provide a more intimate and often a more dynamic relationship with the viewer than those found in monumental art. While the diminutive size of an illumination makes it visually more suited to a small audience, generally a single owner, the image takes on an added dimension and importance from its association with a text, describing, explaining, and sometimes even substituting for the written word. In the Middle Ages and the Renaissance the most sacred text was the Bible. Imagery derived from Old and New Testament stories also illustrated Missals, Breviaries, and other liturgical books used by clergy and choir during church services, as well as the Books of Hours and Saints' Lives consulted by the laity. Pictures served various functions in religious texts: those decorating the initials in huge choirbooks identified the music for particular feast days and were large enough to be shared by a group, while the miniatures in Books of Hours were geared to private meditation.

Beginning with the Book of Genesis and the creation of the world, Old Testament illustrations present a visual historical background to events leading up to the coming of Christ. Artists chose scenes that offered the

most compelling possibilities for the telling of a story. For example, Clovio's sixteenth-century God the Father is a powerful physical presence in three-dimensional space, creating Heaven and Earth with sweeping gestures of his arms (page 24), while three hundred years earlier a different feeling is evoked by flattened figures placed against an ethereal gold ground (pages 26–27). After the flood, animals are pictured leaping from Noah's Ark (page 30), and the stark white figure of Lot's wife turned into a pillar of salt dramatically faces the dissolute inhabitants of Sodom and Gomorrah (page 31).

Pictorial cycles of key events in the lives of Christ and the Virgin Mary often preface Psalters and Books of Hours and fulfilled various functions. Stylized poses and gestures convey the ritualistic aspects of sacred history, while details from everyday life and contemporaneous dress emphasize the holy figures' humanity and bring them closer to the reader. Familiar compositions and easily recognizable scenes also serve as guideposts, making it possible for even the illiterate to follow prayers or church services. For example, in a frontal, highly iconic representation, the Virgin offers an anatomically inaccurate breast to the infant Christ as a symbol of maternity and nurture (page 46); a more homely scene depicts the Holy Family at daily activities while the Child learns to use a walker (page 50). More spiritual issues are addressed in the inter-

pretations of the Baptism of Christ, sometimes accompanied by a totemlike rendition of the Trinity (page 53), and the Dormition of the Virgin, where angels carry the white-robed soul of the Virgin in a hammocklike vessel to the waiting arms of Christ in Heaven (page 67).

At the end of the Bible, the Book of Revelation records the apocalyptic visions of John on the Island of Patmos (page 72). The text is replete with vivid descriptions of unusual phenomena: death and destruction, burning mountains, and hideous beasts (pages 74–75). Artists were challenged to express these scenes pictorially, and used pattern and color, composition, and gesture in symbolic and mimetic combinations to evoke the cataclysmic events of the Last Judgment. At the end, a vision of peace follows the creation of the New Jerusalem, a place where the Lamb of God and his faithful servants will dwell forever (page 82).

Note: in the captions that follow, dimensions are those of the full manuscript page. All manuscripts are on vellum unless otherwise noted.

GIULIO CLOVIO (1498–1578).
*Creation,* from *The Farnese Hours,* 1546.
Rome, Italy. 6¾ x 4¼ in. (173 x 110 mm).
M.69, fol. 59v, detail.

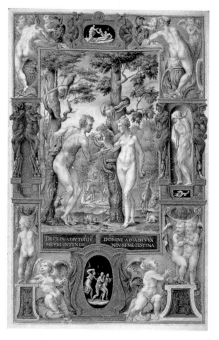

GIULIO CLOVIO (1498–1578).
*Fall of Man*, from *The Farnese Hours*, 1546.
Rome, Italy. 6¾ x 4¼ in. (173 x 110 mm).
M.69, fol. 27.

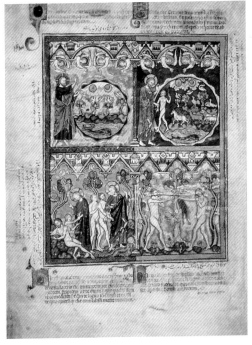

*Creation of Fishes and Birds; Animals and Man;*
*Creation of Eve and God's Warning; Fall of Man,*
from *Old Testament Miniatures,* 1240s. Paris, France.
15⅜ x 12 in. (390 x 304 mm). M.638, fol. 1v.

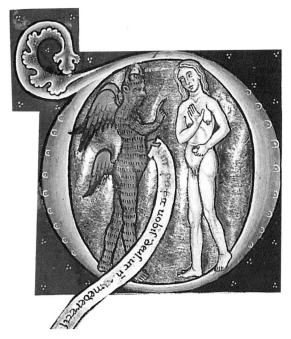

The Ingeborg Psalter Workshop.
*The Devil Tempts Eve,* from Psalter with commentary of Simon
of Tournai, late 12th century. Tournai?, Belgium.
13⅛ x 9⅛ in. (335 x 238 mm). M.338, fol. 45, detail.

28

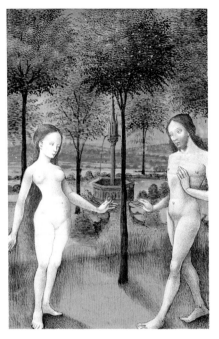

Jean Colombe (documented 1463–93).
*Eve Offers the Fruit to Adam,* from *The Hours of Anne de France,*
c. 1473. Bourges, France. 5¾ x 4¼ in. (147 x 110 mm).
M.677, fol. 48v, detail.

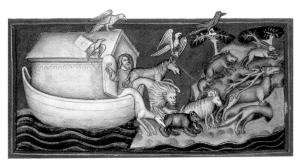

*Animals Leaving Noah's Ark,* from *Universal Chronicle,* c. 1360. Regensburg?, Germany. 13½ x 9½ in. (343 x 242 mm). M.769, fol. 23, detail.

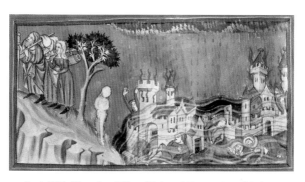

*Lot's Wife Turned to Pillar of Salt and Destruction of Sodom,*
from *Universal Chronicle,* c. 1360. Regensburg?, Germany.
13½ x 9½ in. (343 x 242 mm). M.769, fol. 44, detail.

GIULIO CLOVIO (1498–1578).
*Meeting of Solomon and Sheba*, from *The Farnese Hours*, 1546.
Rome, Italy. 6¾ x 4¼ in. (173 x 110 mm). M.69, fol. 39.

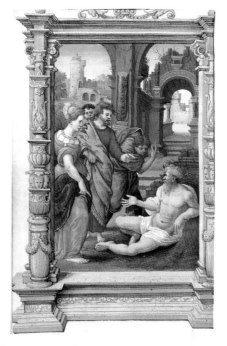

MASTER OF THE GETTY EPISTLES (act. 1520s–1530s).
*Job on the Dungheap*, from Book of Hours, c. 1530–35.
Tours?, France. 5½ x 3¼ in. (138 x 90 mm). M.452, fol. 97v.

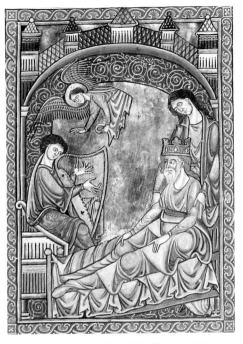

*David Harping before Saul,* from *The Hachette Psalter,* c. 1225.
London?, England. 13 x 8⅝ in. (332 x 220 mm).
G.25, fol. 3v, detail.

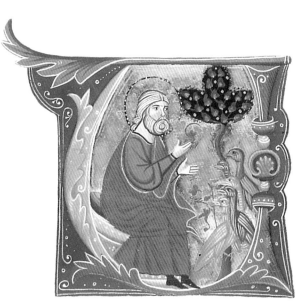

*Joel Preaching to the Birds,* from Bible, c. 1300.
Padua, Italy. 16¾ x 10½ in. (425 x 265 mm).
M.436, fol. 313, detail.

35

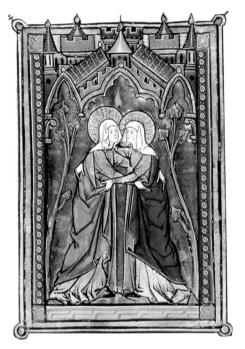

*Visitation,* from Psalter, c. 1260s–1270s.
Bruges or Ghent, Belgium.
5⅝ x 3¾ in. (145 x 100 mm). M.97, fol. 8v, detail.

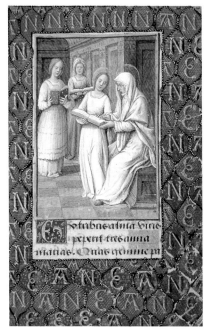

JEAN POYET (act. c. 1465–?1503).
*Education of the Virgin,* from
*The Prayer Book of Anne de Bretagne,* c. 1495.
Tours, France. 4⅞ x 3⅛ in. (125 x 80 mm). M.50, fol. 13.

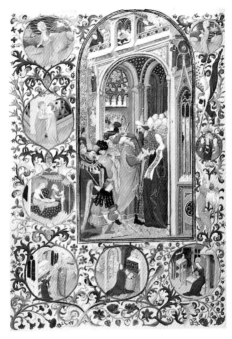

MASTER OF MORGAN 453 (act. 1420s–30s).
*Betrothal of the Virgin,* from Book of Hours, c. 1425–30.
Paris, France. 8¾ x 6 in. (222 x 156 mm).
M.453, fol. 30v.

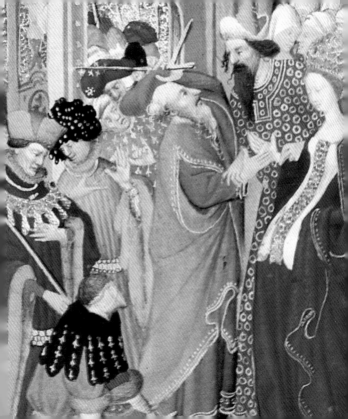

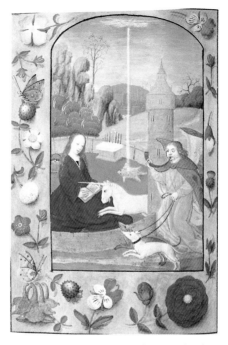

*Hunt of the Unicorn Annunciation,* from Book of Hours,
c. 1500. Probably Antwerp, Belgium.
8⅛ x 6⅛ in. (207 x 157 mm). G.5, fol. 18v, detail.

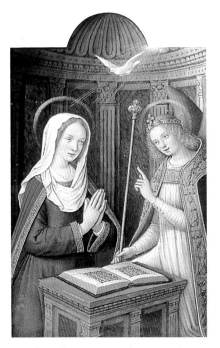

JEAN BOURDICHON (1457–1521).
*Annunciation*, from Book of Hours, c. 1515. Tours, France.
12 x 7⅝ in. (302 x 200 mm). M.732, fol. 3v, detail.

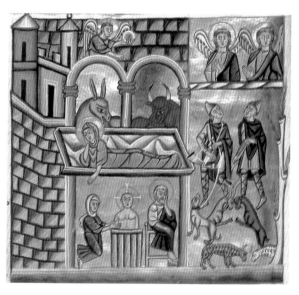

*Nativity and Annunciation to Shepherds,* from Gospel Lectionary,
c. 1050. Abbey of St. Peter, Salzburg, Austria.
10½ x 8⅛ in. (267 x 210 mm). G.44, fol. 2v, detail.

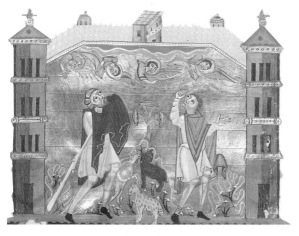

*Annunciation to the Shepherds,* from Gospels, 1st half
of the 11th century. Abbey of St. Peter, Salzburg, Austria.
13½ x 10½ in. (343 x 266 mm). M.781, fol. 134, detail.

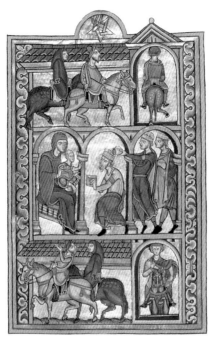

MASTER OF THE BERTHOLD SACRAMENTARY.
*Journey of the Magi,* from *The Berthold Sacramentary,* c. 1215–17.
Weingarten Abbey, Germany. 11½ x 8 in. (293 x 204 mm).
M.710, fol. 19v, detail.

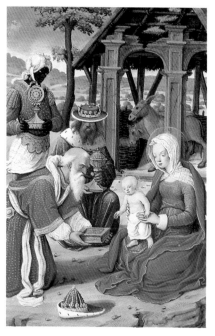

JEAN POYET (act. c. 1465–?1503).
*Adoration of the Magi,* from *The Hours of Henry VIII,* c. 1500.
Tours, France. 10⅛ x 7⅛ in. (256 x 180 mm).
H.8, fol. 61v, detail.

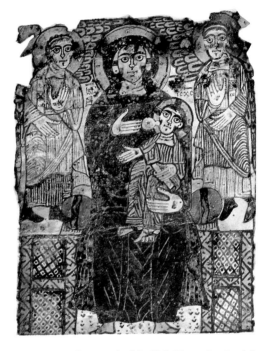

*Virgo Lactans*, from *Book of the Holy Hermeniae*, 897/98.
Toutôn in the Fayum, Egypt.
11 x 8⅝ in. (280 x 220 mm). M.574, fol. 1v, detail.

*Circumcision,* from *The Hours of Cecilia Gonzaga,*
c. 1470. Milan?, Italy.
7¼ x 5¼ in. (185 x 132 mm). M.454, fol. 200, detail.

*Slaughter of the Innocents,* from
*The Psalter and Book of Hours of Yolande de Soissons,*
c. 1280s. Amiens, France.
7⅛ x 5⅛ in. (182 x 134 mm). M.729, fol. 296v.

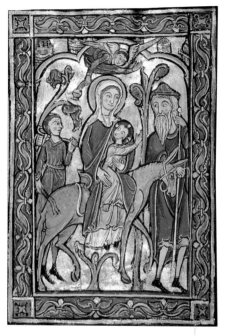

*Flight into Egypt,* from *Miniatures of the Life of Christ,*
c. 1200. Limoges?, France.
9⅝ x 6⅝ in. (340 x 222 mm). M.44, fol. 3, detail.

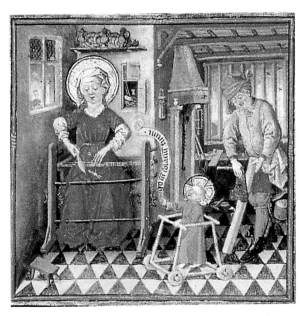

MASTER OF CATHERINE OF CLEVES (act. c. 1430–60).
*Holy Family,* from *The Hours of Catherine of Cleves,* c. 1440.
Utrecht, Netherlands. 7½ x 5 in. (192 x 130 mm).
M.917, p. 149, detail.

*Return from Egypt*, from *The Hours of Cecilia Gonzaga*,
c. 1470. Milan?, Italy.
7¼ x 5¼ in. (185 x 132 mm).
M.454, fol. 217.

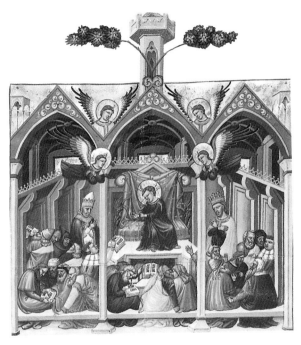

MASTER OF 1328 (act. c. 1318–36).
*Jesus among the Doctors,* from Boniface VIII, *Decretals,* c. 1330.
Bologna, Italy. 18 x 11¼ in. (460 x 283 mm).
M.821, single leaf, detail.

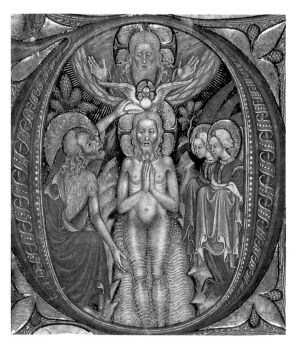

OLIVETAN MASTER (act. second quarter 15th century).
*Baptism of Christ,* cutting from Choir Book, c. 1435–40.
Milan, Italy. 6⅛ x 5¾ in. (157 x 147 mm). M.558.2.

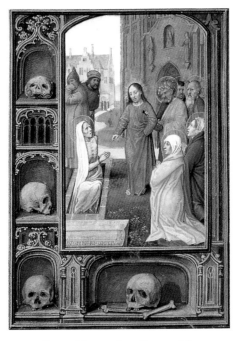

SIMON BENING (c. 1483–c. 1561).
*Resurrection of Lazarus,* from *The Da Costa Hours,* c. 1515.
Bruges, Belgium. 6¾ x 4⅞ in. (172 x 125 mm).
M.399, fol. 226v.

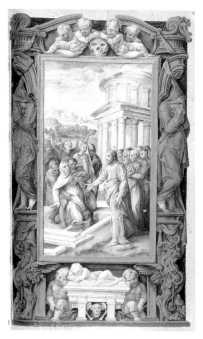

GIULIO CLOVIO (1498–1578).
*Raising of Lazarus,* from *The Farnese Hours,* 1546.
Rome, Italy. 6¾ x 4¼ in. (173 x 110 mm).
M.69, fol. 80.

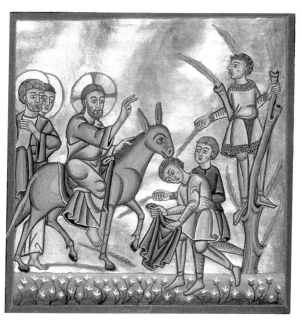

*Entry into Jerusalem,* from Gospel Lectionary, c. 1050.
Abbey of St. Peter, Salzburg, Austria.
10½ x 8⅛ in. (267 x 210 mm). G.44, fol. 58v, detail.

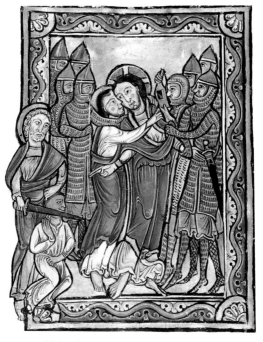

*Kiss of Judas,* from *Miniatures from the Life of Christ,*
c. 1200. Limoges?, France.
9⅝ x 6⅝ in. (340 x 222 mm). M.44, fol. 7v, detail.

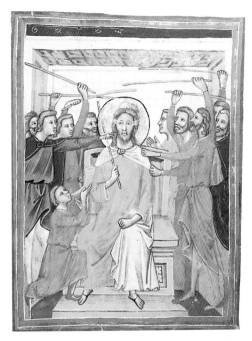

PACINO DA BONAGUIDA (act. c. 1300–c. 1340).
*Mocking of Christ, from Miniatures of the Life of Christ and Blessed Gerardo da Villamagna*, c. 1330. Florence, Italy.
9⅝ x 6¾ in. (245 x 176 mm). M.643, p. 20, detail.

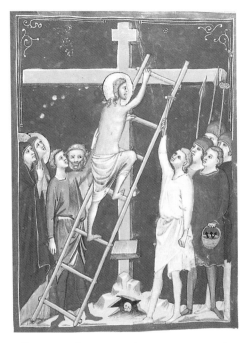

PACINO DA BONAGUIDA (act. c. 1300–c. 1340).
*Christ Ascending the Cross,* from *Miniatures of the Life of Christ and Blessed Gerardo da Villamagna,* c. 1330. Florence, Italy. 9⅝ x 6¾ in. (245 x 176 mm). M.643, p. 22, detail.

59

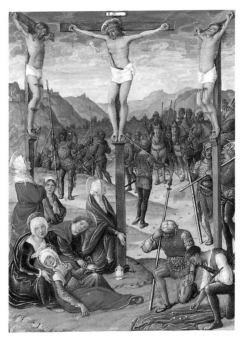

JEAN POYET (act. c. 1465-?1503).
*Crucifixion*, from *The Lallemant Missal*,
c. 1490-1500. Tours, France. 13½ x 8½ in. (345 x 225 mm).
M.495, fol. 86, detail.

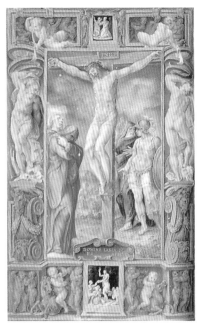

GIULIO CLOVIO (1498–1578).
*Crucifixion,* from *The Farnese Hours,* 1546.
Rome, Italy. 6¾ x 4¼ in. (173 x 110 mm).
M.69, fol. 102v.

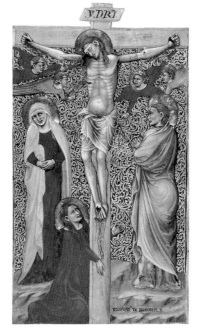

NICCOLÒ DA BOLOGNA (c. 1330–c. 1402)
*Crucifixion,* from Ordinal, c. 1370. Bologna, Italy.
9 x 6¼ in. (228 x 160 mm). M.800, fol. 39v, detail.

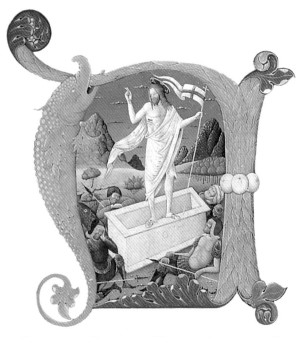

Francesco da Castello, or Workshop (act. 1460s–80s).
*Resurrection*, from *Lodi Cathedral Antiphonary*,
last third 15th century. Milan?, Italy.
21½ x 16 in. (545 x 407 mm). M.686, fol. 3, detail. 63

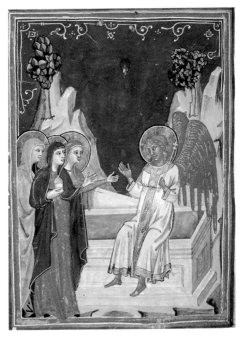

PACINO DA BONAGUIDA (c. 1300–c. 1340).
*Three Marys at the Tomb*, from *Miniatures of the Life of Christ and Blessed Gerardo da Villamagna*, c. 1330. Florence, Italy.
9⅝ x 6¾ in. (245 x 176 mm). M.643, p. 26, detail.

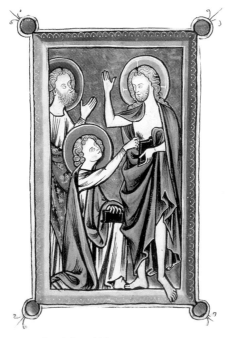

*Incredulity of Thomas,* from Psalter,
3rd quarter 13th century. Bruges, Belgium.
9½ x 6½ in. (235 x 165 mm). M.106, fol. 88v, detail.

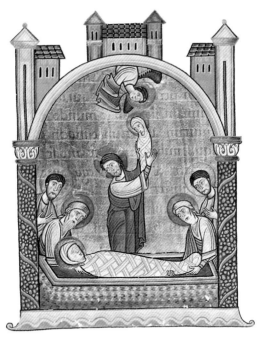

CUSTOS PERHTOLT.
*Entombment of the Virgin,* from Gospel Lectionary, 1070s.
Abbey of St. Peter, Salzburg, Austria.
9⅝ x 7¼ in. (245 x 182 mm). M.780, fol. 64v, detail.

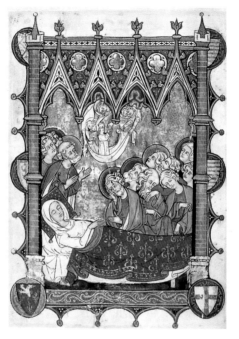

*Dormition of the Virgin,* from *The Psalter and Book of Hours of Yolande de Soissons,* c. 1280s. Amiens, France.
7⅛ x 5⅛ in. (182 x 134 mm). M.729, fol. 305v.

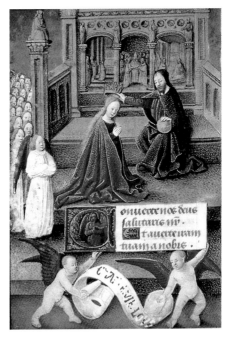

JEAN COLOMBE (doc. 1463–93).
*Coronation of the Virgin,* from *The Hours of Jean Robertet,*
c. 1470. Bourges, France. 4¼ x 3⅛ in.
(108 x 80 mm). M.834, fol. 76v, detail.

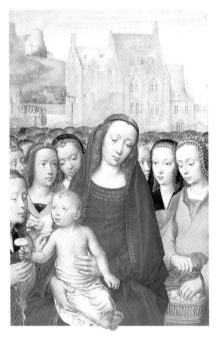

GERARD DAVID (act. c. 1480–1523).
*Virgin and Child among Virgins,* from Breviary?, c. 1500.
Bruges, Belgium. 7⅛ x 5¼ in. (183 x 133 mm).
M.659, single leaf, detail.

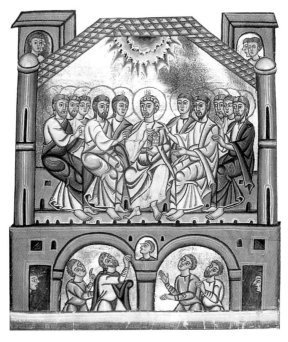

*Pentecost,* from Gospel Lectionary, c. 1050.
Abbey of St. Peter, Salzburg, Austria.
10½ x 8⅛ in. (267 x 210 mm). G.44, fol. 103, detail.

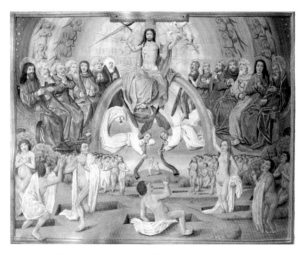

MASTER OF EDWARD IV (act. 1470s–1480s).
*Last Judgment,* from *Ludolphus de Saxonia, Vita Christi,* c. 1485.
Bruges, Belgium. 18⅛ x 13 in. (470 x 331 mm).
M.894, fol. 216v, detail.

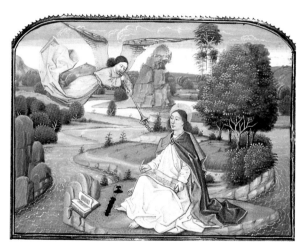

LOYSET LIÉDET (act. c. 1461–78).
*St. John Writing the Apocalypse,* from Epistolary and Apocalypse,
third quarter 15th century. Bruges, Belgium.
72    14 x 10 in. (238 x 163 mm). M.68, fol. 159, detail.

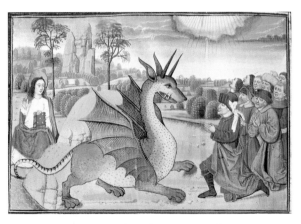

Loyset Liédet (act. c. 1461–78).
*Men Adoring Beast with Two Horns,* from Epistolary and
Apocalypse, third quarter 15th century. Bruges, Belgium.
14 x 10 in. (238 x 163 mm). M.68, fol. 201v, detail.

73

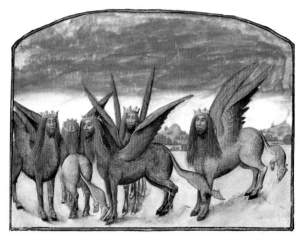

MASTER OF THE MORAL TREATISES (act. 1470s).
*The Plague of Locusts,* from *The Apocalypse of Margaret of York,*
c. 1475. Ghent, Belgium. 14¼ x 10¼ in. (362 x 265 mm).
M.484, fol. 48v, detail.

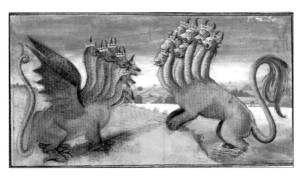

MASTER OF THE MORAL TREATISES (act. 1470s).
*The Dragon and the Beast,* from *The Apocalypse of Margaret
of York,* c. 1475. Ghent, Belgium. 14¼ x 10¼ in.
(362 x 265 mm). M.484, fol. 64, detail.

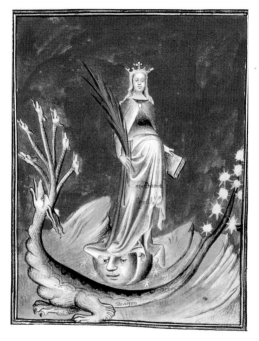

MASTER OF THE BERRY APOCALYPSE (act. 1410s).
*The Madonna of the Apocalypse,* from *The Berry Apocalypse,*
c. 1415. Paris, France. 12 x 8¼ in. (302 x 208 mm).
M.133, fol. 36v, detail.

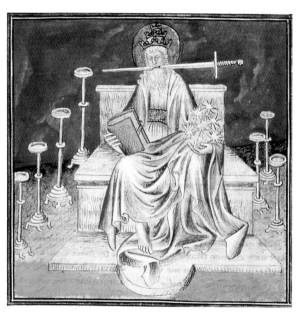

MASTER OF THE BERRY APOCALYPSE (act. 1410s).
*Vision of the Son of Man and the Seven Candlesticks,*
from *The Berry Apocalypse,* c. 1415. Paris, France.
12 x 8¼ in. (302 x 208 mm). M.133, fol. 4v, detail.

77

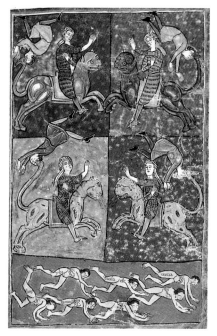

*Four Horsemen and Serpent Tails,*
from Beatus of Liébana, *Commentary on the Apocalypse,* 1220.
Burgos?, Spain. 20½ x 14¼ in. (520 x 370 mm).
M.429, fol. 94, detail.

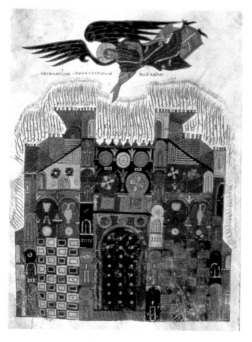

MAIUS (d. 968).
*Destruction of Babylon,* from Beatus of Liébana,
*Commentary on the Apocalypse,* c. 950. San Salvador de Tábara,
Spain. 15 x 11 in. (385 x 280 mm). M.644, fol. 202v.

79

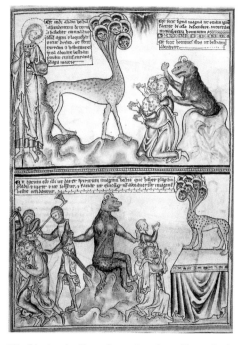

*Worshipping the Beast*, from *Apocalypse Picture Book*,
c. 1260. London?, England.
10¾ x 7¾ in. (271 x 195 mm). M.524, fol. 11v, detail.

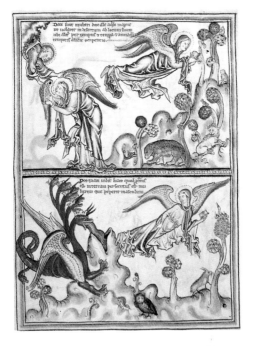

*Woman Receives Wings and Her Flight; Pursuit of the Dragon,*
from *Apocalypse Picture Book,* c. 1260. London?, England.
10¾ x 7¾ in. (271 x 195 mm). M.524, fol. 9v, detail.

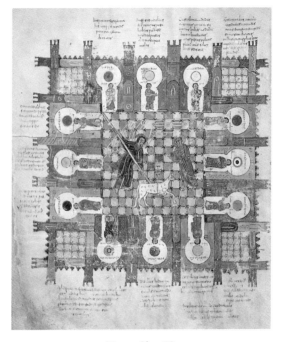

MAIUS (d. 968).
*New Jerusalem,* from Beatus of Liébana, *Commentary
on the Apocalypse,* c. 950. San Salvador de Tábara, Spain.
15 x 11 in. (385 x 280 mm). M.644, fol. 222v.

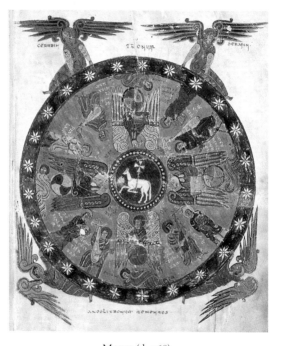

CERUBIN  TΣ ONИ̃A  SERAFIN

ANGELIBONИ̃A AENИ̃RIES

MAIUS (d. 968).
*Vision of the Lamb*, from Beatus of Liébana, *Commentary on the Apocalypse*, c. 950. San Salvador de Tábara, Spain. 15 x 11 in. (385 x 280 mm). M.644, fol. 87.

MAIUS (d. 968).
*Dream of Nebuchadnezzar,* from St. Jerome, *Commentary
on Daniel,* c. 950. San Salvador de Tábara, Spain.
15 x 11 in. (385 x 280 mm). M.644, fol. 252v.

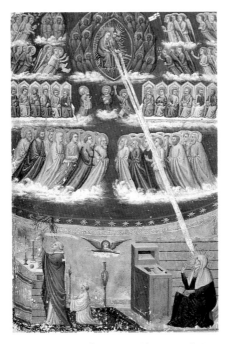

*Heavenly Vision,* from St. Bridget, *Revelations,*
last quarter 14th century. Naples, Italy.
10½ x 7¼ in. (268 x 192 mm).
M.498, fol. 4v, detail.

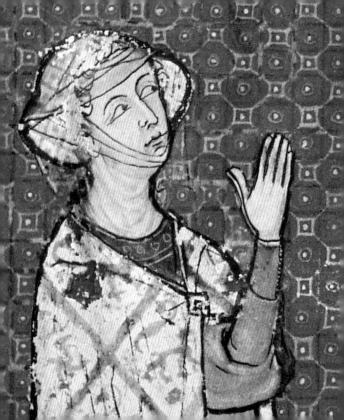

# SAINTS, RITES, AND RITUALS

Miniatures illustrate the religious rituals of both secular and ecclesiastic daily life. The Church accompanied the life of every Christian from birth to death: the rite of baptism welcomed the individual, high- or lowborn, into the religious congregation (page 114); the union of a couple was celebrated at the marriage ceremony; last rites purified the dying and prepared them for death (pages 115 and 117). In the church, funeral services recalled the life of the deceased and commended the soul to God (page 118); a graveside service provided a final farewell to the body, committing it to the dust from which it had sprung (page 119). Christians knew their souls would be weighed at the day of Judgment, and that the Archangel Michael would battle the devil and his demonic servants for the souls of the good (pages 97, 104–5, and 116). Hell awaited those who had succumbed to the temptations of the seven deadly sins of lust, pride, anger, gluttony, envy, sloth, and avarice, represented in one manuscript by the demons and animals associated with such vices (pages 123–29).

Pictured too are the emblems of religious life, with a view to facilitating the viewers' understanding of theological concepts and doctrine and providing a focus for devotions. The Host, literally the Body of Christ to the medieval

Christian, is shown in a monstrance, a vessel for its display (page 134); representations of the cross on which Christ was crucified and the instruments of his Passion evoked Christ's suffering and pain and inspired meditation (pages 132–33). The Virgin instituted the rosary, an aid to prayers (page 135). Owners of Books of Hours often had themselves represented in prayer before a holy figure, most commonly the Virgin, with or without the Child, to express their devotion or to appeal for intercession (pages 86 and 110).

Religious figures are represented in the fulfillment of their daily rituals. Missals, which contain the liturgy of the Mass and ceremonial instructions for the clergy, often have a miniature to mark the moment when the priest, attended by acolytes, faces the altar and raises high the Host for the congregation to view (page 121). There are also pictures of the sacraments, such as baptism (page 114) and last rites (pages 115–17). The pope, head of the Church on earth, may be depicted accompanied by the symbols of his office; an especially elaborate composition documents Pope Leo X's ceremonial reception of his liturgical shoes in preparation for celebrating the Mass (page 131).

Life in the Middle Ages was not only fraught with disease, disasters, and violence, but for Christians was also punctuated by a fear of the devil and the tortures of Hell. The devout would call upon the saints to protect

them from natural dangers, and to intercede for the good of their souls. The protection saints offered was often linked to main events in their lives or to the manner of their deaths and martyrdoms, usually the scenes chosen for their depiction. Thus Lucy, whose eyes were gouged out, is considered a patroness of eyesight; Bartholomew, who was flayed, represents those who work with all types of skins and leather (page 92–93); and Margaret, who was swallowed by the devil in the form of a dragon and then caused it to expel her alive, is called upon for assistance in childbirth. While some holy figures are clothed in generic flowing robes and draperies, saints are sometimes presented in contemporaneous dress, as though they were living in the artist's time. In this way one can see the fashions and styles of the period.

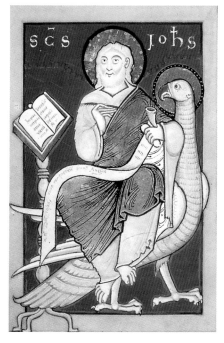

*St. John the Evangelist,* from *The Mostyn Gospels,* c. 1130.
Gloucester?, England.
10⅜ x 6⅝ in. (264 x 172 mm). M.777, fol. 58v, detail.

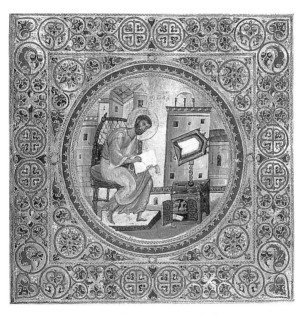

*St. Mark,* from Gospel Lectionary, end of 11th century.
Constantinople, Byzantium.
13 x 10 in. (332 x 255 mm). M.639, fol. 218, detail.

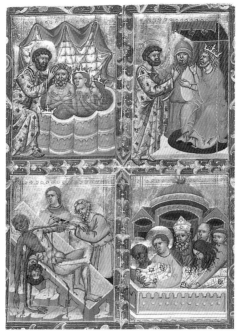

*St. Bartholomew Baptizing King Polemius and His Family: His Arrest, Flaying, and Entombment,* from *The Anjou Legendary,* c. 1320–c. 1340. Hungary, Bolognese illuminator.

92        8½ x 6½ in. (215 x 165 mm). M.360, fol. 21.

CUSTOS PERHTOLT.
*Lapidation of St. Stephen,* from Gospel Lectionary, 1070s.
Abbey of St. Peter, Salzburg, Austria.
9⅝ x 7¼ in. (245 x 182 mm). M.780, fol. 6v, detail.

MASTER OF THE BERTHOLD SACRAMENTARY.
*St. Lawrence on the Grill,* from *The Berthold Sacramentary,*
c. 1215–17. Weingarten Abbey, Germany.
11½ x 8 in. (293 x 204 mm). M.710, fol. 104v, detail.

95

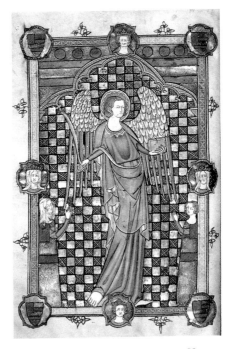

*Archangel Gabriel,* from *The De Bois Hours,*
c. 1325–30. South-central England.
12½ x 8½ in. (318 x 216 mm). M.700, fol. 1v.

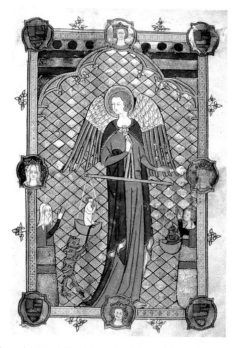

*Archangel Michael Weighing a Soul,* from *The De Bois Hours,*
c. 1325–30. South-central England.
12½ x 8½ in. (318 x 216 mm). M.700, fol. 2.

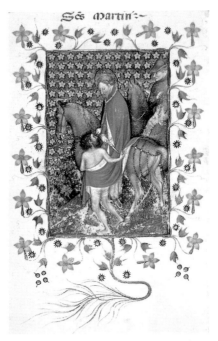

Sc̄s Martin

MICHELINO DA BESOZZO (act. late 14th century–c. 1449).
*St. Martin Dividing His Cloak,* from Prayer Book,
c. 1420. Milan, Italy.
6¾ x 4¾ in. (172 x 122 mm). M.944, fol. 80v.

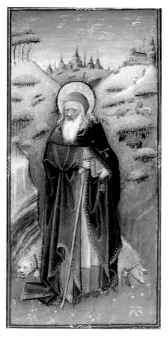

MASTERS OF ZWEDER VAN CULEMBORG (act. c. 1415–40).
*St. Anthony,* from *The Egmont Breviary,*
c. 1435–40. Utrecht, Netherlands.
9⅝ x 7 in. (242 x 165 mm). M.87, fol. 327v, detail.

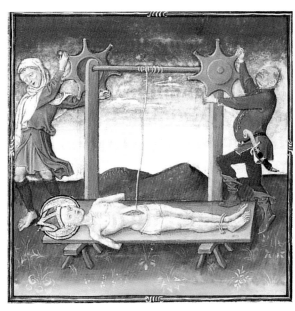

MASTER OF CATHERINE OF CLEVES (act. c. 1430-60).
*Martyrdom of St. Erasmus,* from *The Hours of Catherine of Cleves,*
c. 1440. Utrecht, Netherlands.

7½ x 5 in. (192 x 130 mm). M.917, p. 258, detail.

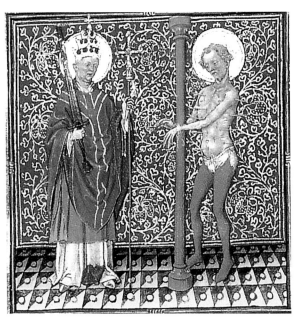

Master of Catherine of Cleves (act. c. 1430–60).
*St. Fabian and St. Sebastian,* from *The Hours of Catherine of Cleves,* c. 1440. Utrecht, Netherlands.
7½ x 5 in. (192 x 130 mm). M.917, p. 253, detail.  101

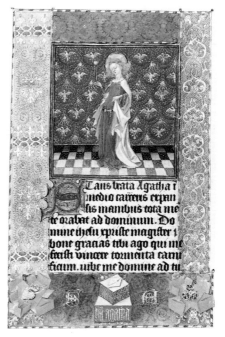

MASTER OF CATHERINE OF CLEVES (act. c. 1430–60).
*St. Agatha*, from *The Hours of Catherine of Cleves*,
c. 1440. Utrecht, Netherlands.
7½ x 5 in. (192 x 130 mm). M.917, p. 306.

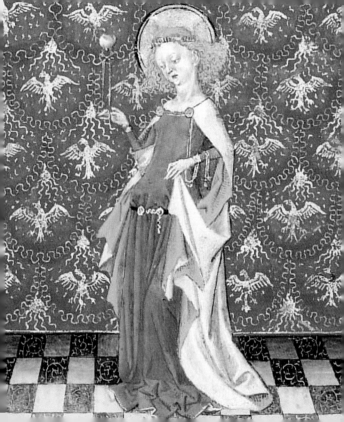

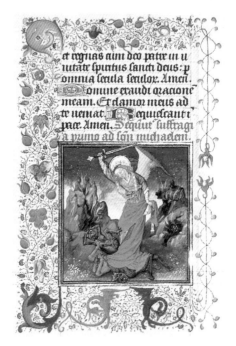

et regnas aim deo patre in u
nitate spiritus sancti deus: p
omnia secula seculorum. Amen
Domine exaudi oracone
meam. Et clamor meus ad
te veniat. Requiescant in
pace. Amen. Sequitur suffragi
a primo ad sanctum michaelem.

MASTER OF CATHERINE OF CLEVES (act. c. 1430–60).
*St. Michael Battling Demons,* from *The Hours of Catherine
of Cleves,* c. 1440. Utrecht, Netherlands.
7½ x 5 in. (192 x 130 mm). M.917, p. 204.

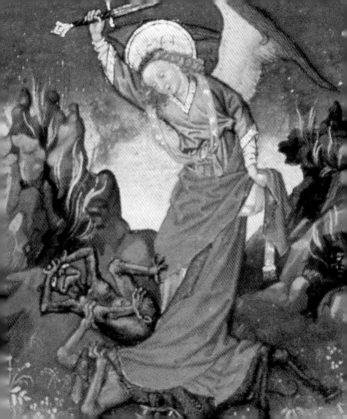

*St. Veronica,* from Book of Hours,
c. 1440. Tournai, Belgium.
7¾ x 5½ in. (197 x 140 mm). M.357, fol. 249, detail.

Within the image:
Oulon du saint sacremente
n presencia corporis et san
guinis tui domine ihesu
rpuste commendo tibi me

*The Mass of St. Gregory,* from Book of Hours,
c. 1440. Tournai, Belgium.
7¾ x 5½ in. (197 x 140 mm). M.357, fol. 142, detail.

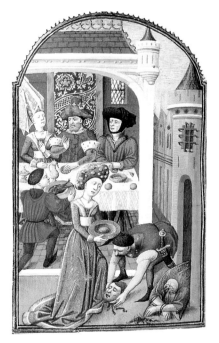

LATE FOLLOWER OF THE MASTER OF THE
MUNICH GOLDEN LEGEND. *Beheading of John the Baptist,*
from Book of Hours, c. 1460. Paris?, France. 6 x 8¾ in.
(153 x 224 mm). M.282, fol. 124v, detail.

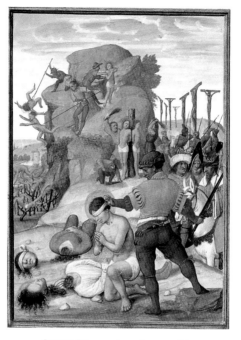

SIMON BENING (c. 1483–c. 1561).
*All Martyrs,* from *The Da Costa Hours,*
c. 1515. Bruges, Belgium.
6¾ x 4⅞ in. (172 x 125 mm). M.399, fol. 295v, detail. 109

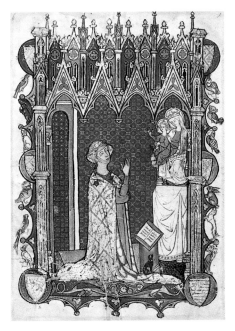

*Yolande de Soissons Praying,* from *The Psalter and
Book of Hours of Yolande de Soissons,* c. 1280s.
Amiens, France.
7⅛ x 5⅛ in. (182 x 134 mm). M.729, fol. 232v.

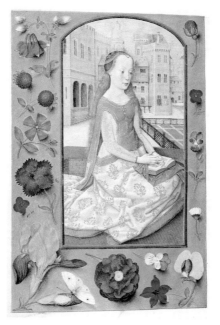

MASTER OF THE OLDER PRAYER BOOK OF MAXIMILIAN I
(Alexander Bening? act. c. 1469–1518).
*St. Barbara,* from *The Breviary of Eleanor of Portugal,*
c. 1500–1510. Ghent or Bruges, Belgium.
9½ x 6¾ in. (240 x 170 mm). M.52, fol. 558v.

111

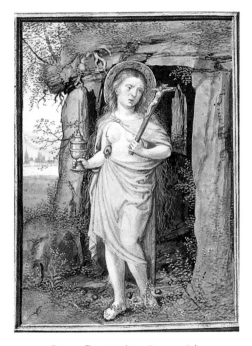

SIMON BENING (c. 1483–c. 1561).
*St. Mary Magdalen,* from *The Van Damme Hours,* 1531.
Bruges, Belgium.
3⅛ x 2¾ in. (74 x 56 mm). M.451, fol. 125v, detail.

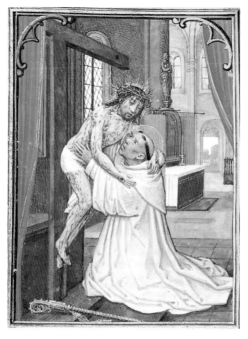

SIMON BENING (c. 1483–c. 1561).
*Vision of St. Bernard,* from *The Van Damme Hours,* 1531.
Bruges, Belgium.
3⅛ x 2¾ in. (74 x 56 mm). M.451, fol. 118v, detail.    113

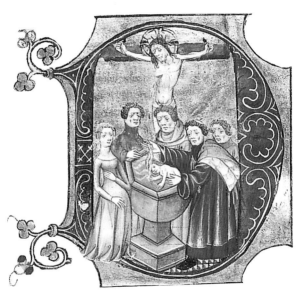

MASTERS OF DIRC VAN DELF (act. c. 1400–1410).
*Baptism,* from Dirc van Delf, *The Table of Christian Faith,*
c. 1405–10. Utrecht, Netherlands.
8⅝ x 6⅛ in. (215 x 153 mm). M.691, fol. 12, detail.

114

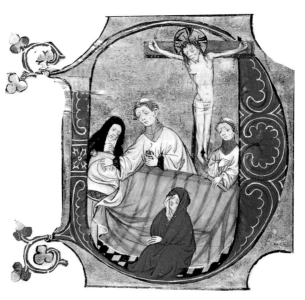

MASTERS OF DIRC VAN DELF (act. c. 1400–c. 1410).
*Last Rites,* from Dirc van Delf, *The Table of Christian Faith,*
c. 1405–10. Utrecht, Netherlands.
8⅝ x 6⅛ in. (215 x 153 mm). M.691, fol. 55v, detail.

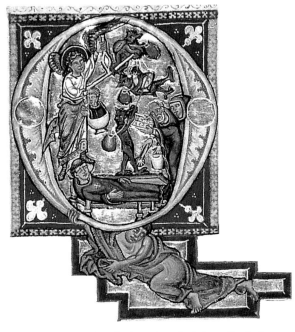

*Last Rites and Michael Weighing Soul,* from Gradual, Sequentiary, and Sacramentary, second half 13th century. Seitenstetten Abbey, Austria.

116      13 x 9 in. (322 x 228 mm). M.855, fol. 206, detail.

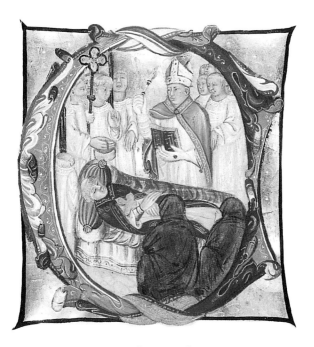

*Last Rites,* from Antiphonary,
early 15th century. Venice?, Italy.
19¼ x 13¼ in. (490 x 338 mm). M.702, single leaf, detail.

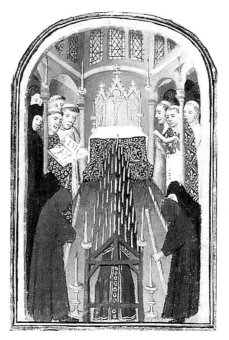

BOUCICAUT MASTER AND WORKSHOP (act. c. 1400–c. 1420).
*Funeral Service,* from *The Strawberry Hours,* c. 1420.
Paris, France. 7⅛ x 5¼ in. (180 x 132 mm).
M.1000, fol. 158, detail.

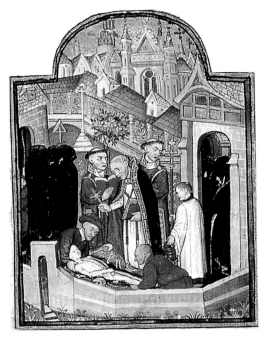

MASTER OF MARGUERITE D'ORLÉANS (act. c. 1430–60).
*Burial,* from *The Hours of Marie de Rieux,* c. 1440s.
Poitiers, France.
8½ x 7⅛ in. (216 x 181 mm). M.190, fol. 1, detail.          119

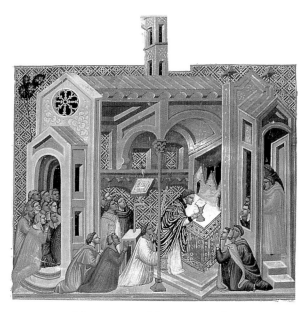

MASTER OF 1328 (act. c. 1318–36).
*Celebration of Mass,* from Gregory IX,
*Decretals,* c. 1330. Bologna, Italy.
15½ x 11 in. (440 x 285 mm). M.716.4, detail.

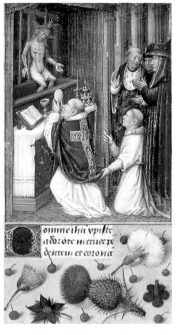

FOLLOWER OF SIMON MARMION (c. 1420/25–1489).
*Mass of St. Gregory,* from Book of Hours, c. 1480.
Northern France and Belgium.
6½ x 4¼ in. (165 x 110 mm). M.6, fol. 154, detail.

121

ALEXIS MASTER AND WORKSHOP.
*Translation of the Body of Edmund*, from *Life, Passion, and Miracles of St. Edmund, King and Martyr*, c. 1130.
Bury St. Edmunds, England.

10¾ x 7½ in. (274 x 187 mm). M.736, fol. 20v, detail.

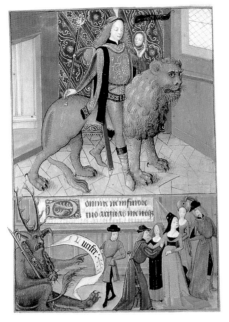

ROBINET TESTARD (act. c. 1470–c. 1531).
*Pride,* from Book of Hours, c. 1475. Poitiers, France.
5⅞ x 4¼ in. (149 x 107 mm). M.1001, fol. 84, detail.

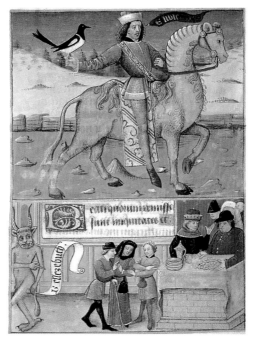

ROBINET TESTARD (act. c. 1470–c. 1531).
*Envy,* from Book of Hours, c. 1475. Poitiers, France.
5⅞ x 4¼ in. (149 x 107 mm). M.1001, fol. 86, detail.

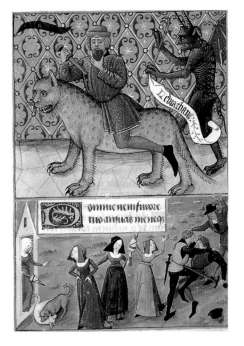

ROBINET TESTARD (act. c. 1470–c. 1531).
*Anger,* from Book of Hours, c. 1475. Poitiers, France.
5⅞ x 4¼ in. (149 x 107 mm). M.1001, fol. 88, detail.

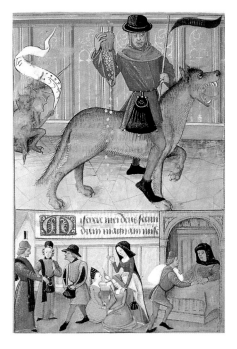

ROBINET TESTARD (act. c. 1470–c. 1531).
*Avarice,* from Book of Hours, c. 1475. Poitiers, France.
5⅞ x 4¼ in. (149 x 107 mm). M.1001, fol. 91, detail.

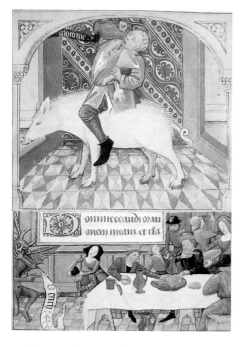

ROBINET TESTARD (act. c. 1470–c. 1531).
*Gluttony,* from Book of Hours, c. 1475. Poitiers, France.
5⅞ x 4¼ in. (149 x 107 mm). M.1001, fol. 94, detail.

ROBINET TESTARD (act. c. 1470–c. 1531).
*Sloth,* from Book of Hours, c. 1475. Poitiers, France.
5⅞ x 4¼ in. (149 x 107 mm). M.1001, fol. 97, detail.

ROBINET TESTARD (act. c. 1470–c. 1531).
*Lust,* from Book of Hours, c. 1475. Poitiers, France.
5⅞ x 4¼ in. (149 x 107 mm). M.1001, fol. 98, detail.

*St. Bridget Receiving a Book with Two Confessors, Who, Below, Present It to a King*, from St. Bridget, *Revelations*, last quarter 14th century. Naples, Italy.

10½ x 7¼ in. (268 x 192 mm). M.498, fol. 343v, detail.

ATTAVANTE DEGLI ATTAVANTI (1452–c. 1520).
*Leo X Receives His Liturgical Shoes*, from *Preparatio ad Missam Pontificalem*, 1520. Rome?, Italy.
15⅝ x 10½ in. (396 x 163 mm). H.6, fol. 1v, detail.   131

TADDEO CRIVELLI (doc. 1452–76).
*The Holy Cross,* from Book of Hours, 1460s.
Ferrara, Italy. 5⅜ x 4 in. (133 x 97 mm). M.227, fol. 92, detail.

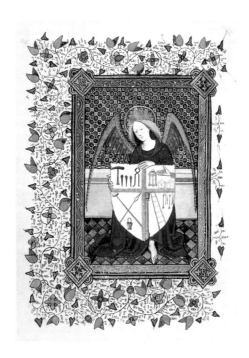

MASTER OF GUILLEBERT DE METS (act. c. 1410–45).
*Arma Christi*, from Book of Hours, c. 1420.
Ghent?, Belgium.
7¼ x 5 in. (185 x 128 mm). M.46, fol. 103v.

133

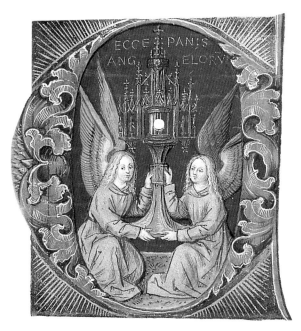

JACOB ELSNER (act. c. 1486–1517).
*Angels Holding Monstrance with Host,* from Gradual
*(The Geese Book),* 1507. Nuremberg, Germany.
134   25¾ x 17¼ in. (654 x 445 mm). M.905, v.I, fol. 209, detail.

*St. Dominic Receives the Rosary from the Virgin*,
from Letter Patent of Nobility, 1721.
San Lorenzo del Escorial, Spain.
11⅞ x 8 in. (304 x 205 mm). M.923, fol. 4, detail.

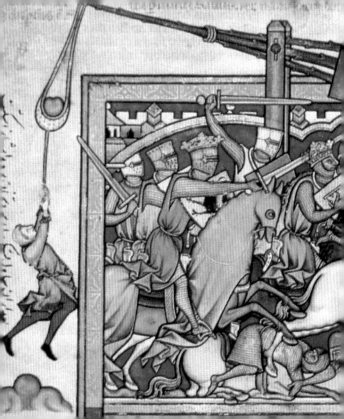

# ROYALTY, PASTIMES, AND PROFESSIONS

Books of Hours and secular manuscripts such as technical manuals and literary works often contain illustrations of everyday life and depictions of people in the exercise of professions, trades, and pursuits of leisure. Some of these representations are fanciful or even idealized, but others use a wealth of verifiable details that evoke the social and economic character of a period. Clothing, both religious and secular, for example, can be very revealing: sleeve and hem lengths, headgear and hair styles, collars and necklines, and the quality of fabrics and their trims are clues to class and occupation. Telling also is the manner in which garments are worn and the body displayed. A nobleman would find unseemly the bare legs and exposed underclothes of the winetreader (page 189); while wonderful jewels adorned the necks of aristocratic laywomen and set off their décolletage (page 161), nuns and abbesses wore simple robes and hair coverings in denial of worldliness or sexuality.

In calendar illustrations we may follow the seasons of the year according to the daily tasks represented: planting in the spring (page 196), shearing sheep in the summer (page 197), harvesting in the fall, slaughtering pigs in the winter (page 199). The technical expertise of workers in

the Middle Ages and Renaissance is often quite sophisticated: witness the complicated traps and snares produced by gamekeepers and hunters, illustrated in the *Livre de la chasse* (pages 187–88). Farming tools and their use and the procedures of animal husbandry, signals of rural life, may be seen in agricultural treatises and manuals (page 193). Craftsmen went through long apprenticeships to learn the specialized trades that improved urban life, and they are often shown at work. They include scribes, who braved writer's cramp to provide readers with much-needed copies of texts (page 184), goldbeaters, who reduced gold coins to paper-thin sheets to guild the backgrounds of panel paintings and miniatures (page 201), and stoneworkers, who shaped the blocks for solid cathedral foundations as well as the delicate arcs of window tracery that turned walls into lace and flooded vast nave interiors with light (pages 182–83).

In contrast to the trades and professions exercised by townsmen and peasants, both more refined and more recreational activities took place at the higher levels of society. To strengthen, promote, and preserve a royal image, rulers were portrayed idealistically, larger than life, at times incorporating the attributes and virtues of gods. Splendidly attired, the king was seen bestowing largesse (page 140), protecting the people (page 142), heading the state (page 144), and taking part in royal ceremonies (page 149). Both royalty and the

aristocracy enjoyed outdoor pastimes that included hunting with falcon or dogs, riding, and boating (pages 168, 173, and 180), or pursued courtly pleasures such as playing board games, listening to music, and feasting (pages 166 and 171). Traveling jugglers, dancers, and musicians entertained the courts, and dancing was also popular among the courtiers and their ladies (page 179).

War and knighthood, masculine pursuits involving complex protective garments and highly decorative trappings, provided opportunities for aristocrats to uphold the prestige and honor of a family name and also display its heraldry. Jousting tournaments were represented in colorful and dynamic compositions (pages 158 and 162) that reflect a medieval love of fanfare; in a more serious vein, some illustrations of hand-to-hand combat convey the unwieldiness of armor, swords, and shields, and suggest the brute force that was needed on the battlefield (pages 154–55). Warfare was not restricted to land, however, and the battles of great crusader ships are sometimes presented with splendid pageantry in panoramic seascapes (page 153). A more detailed view of naval conflict is given in a dramatic closeup of a clash of archers, who fire at each other from vessels that look more like wine casks than seaworthy boats (page 152).

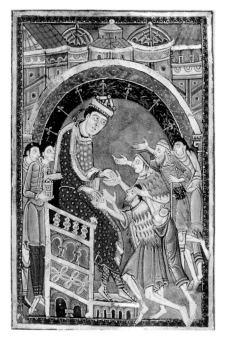

ALEXIS MASTER AND WORKSHOP.
*King Edmund as Alms-giver,* from *Life, Passion, and Miracles of St. Edmund, King and Martyr,* c. 1130. Bury St. Edmunds,
140  England. 10¾ x 7½ in. (274 x 187 mm). M.736, fol. 9, detail.

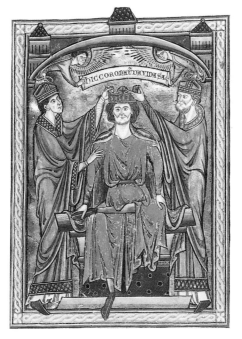

*Coronation of David,* from *The Hachette Psalter,* c. 1225.
London?, England.
13 x 8⅝ in. (330 x 224 mm). G.25, fol. 4, detail.

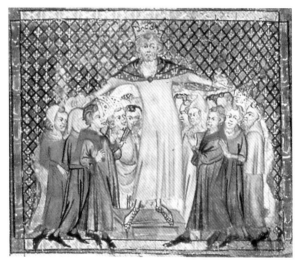

*The King as Protector of His Subjects,* from *Avis aus Roys,*
c. 1360. Paris?, France.
7⅛ x 4⅞ in. (180 x 125 mm). M.456, fol. 6, detail.

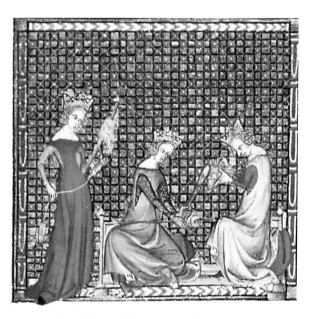

*The Diligence of Queens,* from *Avis aus Roys,*
c. 1360. Paris?, France.
7⅛ x 4⅞ in. (180 x 125 mm). M.456, fol. 56, detail.

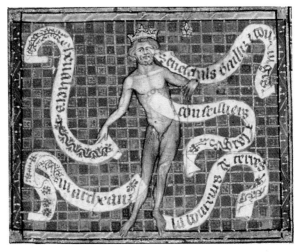

*The King's Body as Allegory of the State,* from *Avis aus Roys,*
c. 1360. Paris?, France.
7⅛ x 4⅞ in. (180 x 125 mm). M.456, fol. 5, detail.

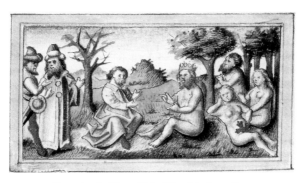

*Alexander the Great Visits King Dindimus,* from
*Book of Alexander,* c. 1460. Augsburg, Germany.
10½ x 7⅞ in. (270 x 200 mm). M.782, fol. 255, detail.

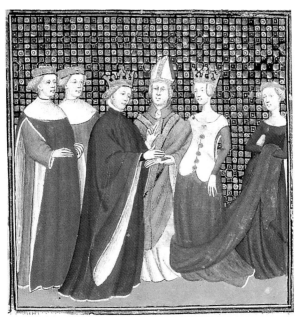

MASTER OF THE CITÉ DES DAMES (act. c. 1401–15).
*Marriage of King Philippe I and Queen Berthe, from Grandes
chroniques de France,* c. 1410–12. Paris, France.

146    16 x 12¾ in. (409 x 325 mm). M.536, fol. 154v, detail.

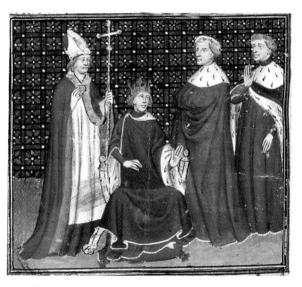

Master of the Cité des Dames (act. c. 1401–15).
*King Philippe V in Peace Conference,* from *Grandes
chroniques de France,* c. 1410–12. Paris, France.
16 x 12¾ in. (409 x 325 mm). M.536, fol. 287v, detail.    147

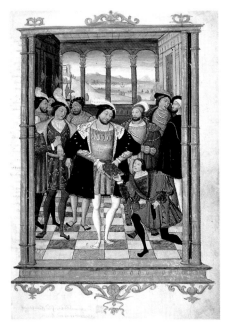

ACARIE MASTER.
*The Scribe Girard Acarie Presents His Book to King Francis I,*
from Guillaume de Lorris and Jean de Meun,
*Roman de la rose,* c. 1525. Rouen, France.
10¼ x 7¼ in. (262 x 186 mm). M.948, fol. 4.

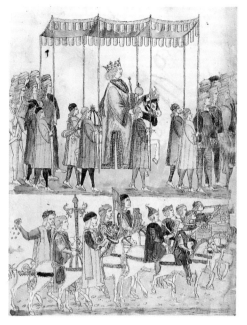

*Alfonso II of Aragon, King of Naples, and His Coronation Cortege,*
from Ferraiolo, *Chronicle of Naples,* end 15th century.
Naples, Italy. Paper, 16⅞ x 11⅛ in. (429 x 284 mm).
M.801, fol. 103.

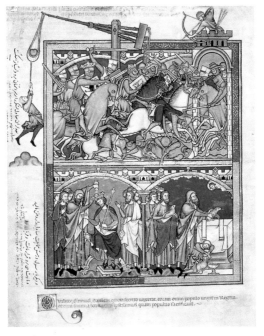

*Saul Destroys Nahash and the Ammonites; Samuel Anoints Saul;*
*Peace Offerings Sacrificed,* from *Old Testament Miniatures,* 1240s.
Paris, France. 15⅜ x 12 in. (390 x 304 mm).
M.638, fol. 23v.

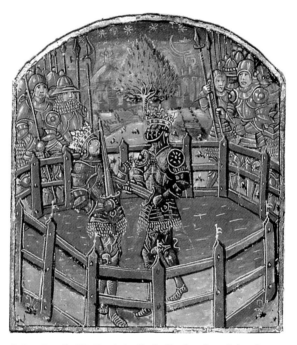

*Codrus Dies for His People in Single Combat,* from John Gower,
*Confessio amantis,* c. 1470. England.
17 x 12½ in. (440 x 320 mm).
M.126, fol. 171, detail.

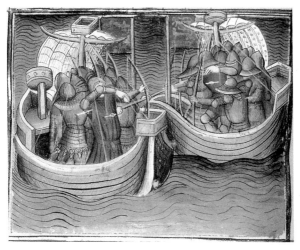

MASTER OF THE BERRY APOCALYPSE WORKSHOP (act. 1410s).
*Battle of Ecluse,* from Jean Froissart, *Chroniques,*
c. 1412. Paris, France.

14½ x 10¾ in. (365 x 272 mm). M.804, fol. 44v, detail.

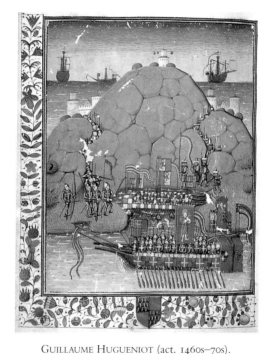

GUILLAUME HUGUENIOT (act. 1460s–70s).
*Knights of Rhodes under George de Bosredont Battle the Turks,*
from *The Hours of Pierre Bosredont,* c. 1465.
Langres, France. 6⅛ x 4⅜ in. (158 x 112 mm). G.55, fol. 140v. 153

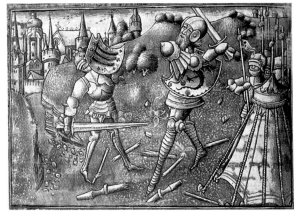

STYLE OF THE MASTER OF CHAMPION DES DAMES.
*Jason Combating Corfus,* from Raoul Le Fèvre,
*L'histoire de Jason,* c. 1470. Lille?, France. Paper,
14¾ x 10½ in. (376 x 260 mm). M.119, fol. 16v, detail.

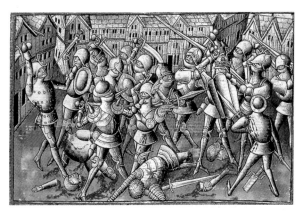

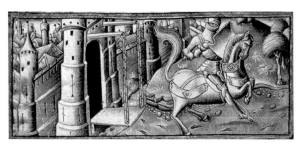

STYLE OF THE MASTER OF CHAMPION DES DAMES.
*Jason Leaving Oliferne,* from Raoul Le Fèvre,
*L'histoire de Jason,* c. 1470. Lille?, France. Paper,
14¾ x 10½ in. (376 x 260 mm). M.119, fol. 29, detail.

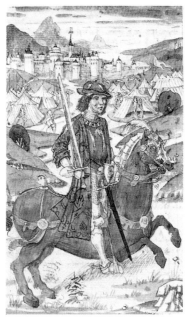

Master of the Bruges Chronicle of Flanders?
(act. c. 1470s–80s). *Equestrian Portrait of Charles of
Burgundy,* from *Chronicle of Flanders from 1420 to 1485,*
end of 15th century. Bruges, Belgium. Paper,
11·x 8 in. (280 x 204 mm). M.435, fol. 352v, detail. 157

*Lancelot Unhorsing Brandus*, from *Le roman de Lancelot du Lac*, early 14th century. Northeastern France. 13⅛ x 10 in. (346 x 255 mm). M.805, fol. 38v, detail.

*Lancelot Crossing a Sword-Bridge to Rescue Guinevere,*
from *Le roman de Lancelot du Lac*, early 14th century. Northeastern France.
13⅜ x 10 in. (346 x 255 mm). M.806, fol. 166, detail.

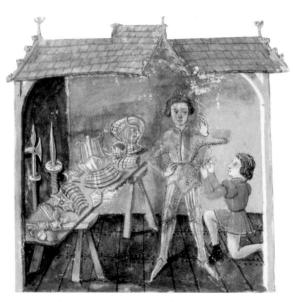

*A Knight Being Armed for Foot Battle,* from *Ordinances of Armoury and Miscellaneous Texts,* mid 15th century. England. 9¾ x 6¾ in. (248 x 172 mm). M.775, fol. 122v, detail.

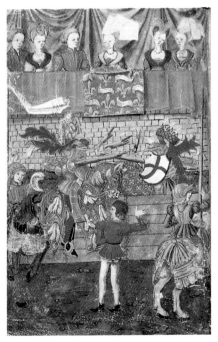

*Sir John Astley (left) Jousting,* from *Ordinances of Armoury and Miscellaneous Texts,* mid 15th century. England. 9¾ x 6¾ in. (248 x 172 mm). M.775, fol. 2v.

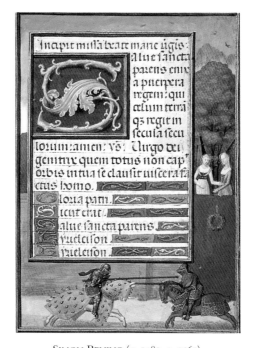

SIMON BENING (c. 1483–c. 1561).
*Two Knights Tilt,* from *The Da Costa Hours,*
c. 1515. Bruges, Belgium.
6¾ x 4⅞ in. (172 x 125 mm). M.399, fol. 370, detail.

162

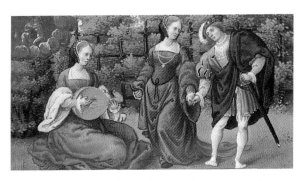

MASTER OF THE GETTY EPISTLES (act. 1520s–30s).
*Spring Pastorale,* from Book of Hours,
c. 1530–35. Tours?, France.
5½ x 3¼ in. (138 x 90 mm). M.452, fol. 6, detail. 163

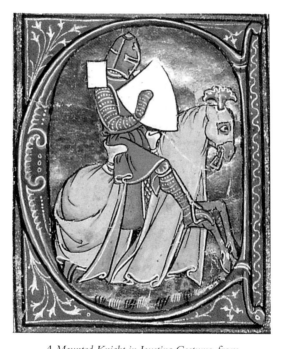

*A Mounted Knight in Jousting Costume,* from
*Le roman de Lancelot du Lac,* early 14th century.
Northeastern France.
13⅝ x 10 in. (346 x 255 mm). M.805, fol. 37v, detail.

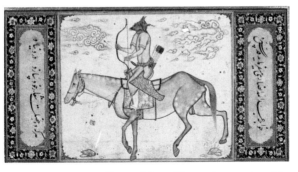

STYLE OF MUHAMMAD ʿALĪ IBN MALIK HUSAIN (act. c. 1630–60).
*Archer on an Aged Horse,* from *The Read Albums,*
c. 1600–c. 1625. Persia.
Paper, 14⅞ x 9½ in. (378 x 241 mm). M.386.18, detail.     165

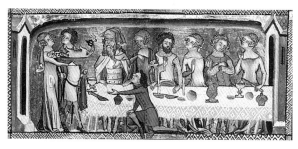

*Peacock Offered to Aristé,* from Jacques de Longuyon,
*Voeux du paon,* c. 1350. Tournai?, Belgium.
9⅝ x 7 in. (245 x 179 mm). G.24, fol. 52, detail.

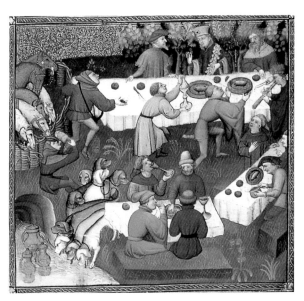

*Meal before the Hunt,* from Gaston Phébus, *Livre de la chasse,*
c. 1410. Paris, France.
15⅛ x 11¼ in. (385 x 287 mm). M.1044, fol. 58, detail.

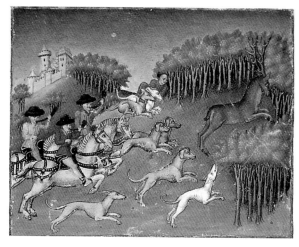

*Hunters and Dogs Chasing Stag,* from Henri de Ferières,
*Livre du roy Modus et de la royne Racio,* c. 1465.
Brittany or Anjou, France.

11½ x 8½ in. (295 x 223 mm). M.820, fol. 12, detail.

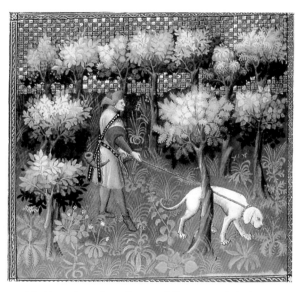

*Tracking a Scent,* from Gaston Phébus, *Livre de la chasse,*
c. 1410. Paris, France.
15⅛ x 11¼ in. (385 x 287 mm). M.1044, fol. 55, detail.

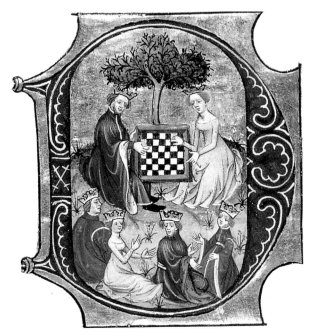

MASTERS OF DIRC VAN DELF (act. c. 1400–c. 1410).
*King and Queen Playing Chess,* from Dirc van Delf, *The Table of Christian Faith,* c. 1405–10. Utrecht, Netherlands.
8⅝ x 6⅛ in. (215 x 153 mm). M.691, fol. 131v, detail.

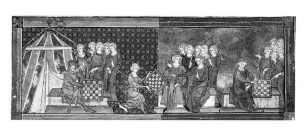

*Lancelot and the Magic Chessboard,* from *Le roman de Lancelot
du Lac,* early 14th century. Northeastern France.
13⅝ x 10 in. (346 x 255 mm). M.806, fol. 253v, detail.

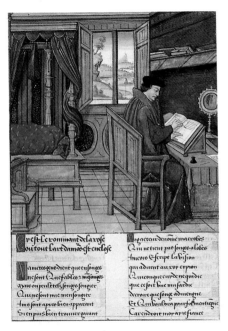

CREST-LE rommant dela rose
ou tout lart damos est enclose

Nainteregene dient que eu songes
Ne sont que sables & mensonge
Amu on peult telz songe songier
Qui ne sont mie mensonger
Ains sont apres bien apparant
Si en puis bien trouuer guarant

Ung acteur denome macrobes
Qui ne tient pas songes a lobes
Aincois escript la vision
qui aduint au roy cypion
Quiconque en ce que dit
Que ce soit bne mis sardie
Acroire que songe aduienne
Et qui voulsir pour soi mentienne
Car endroit moy ai ie fiance

ACARIE MASTER.
*Guillaume de Lorris Writing in His Studio,*
from Guillaume de Lorris and Jean de Meun,
*Roman de la rose,* c. 1525. Rouen, France.
10⁵⁄₁₆ x 7⁷⁄₁₆ in. (262 x 186 mm). M.948, fol. 5.

STYLE OF HABĪB-ALLĀH MASHHADĪ (act. 1595–1610).
*Youth Putting on Falconer's Glove,*
from *The Read Albums,* c. 1600. Herat, Persia.
Paper, 14⅞ x 9½ in. (378 x 241 mm). M.386.4, detail.

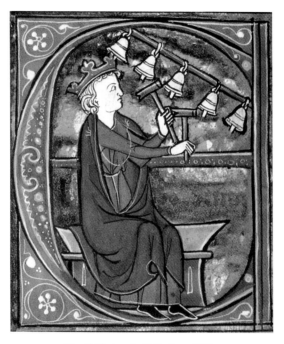

*David Playing the Bells,* from Bible,
third quarter 13th century. Paris, France.
15¼ x 11 in. (390 x 285 mm). M.494, fol. 314v, detail.

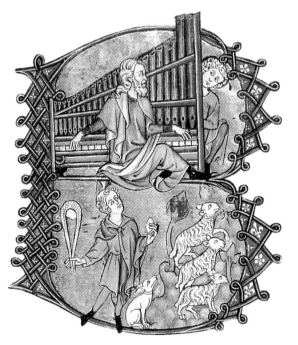

*Man Playing the Organ and David with Sling,* from
*The Psalter and Book of Hours of Yolande de Soissons,* c. 1280s.
Amiens, France.
7⅛ x 5⅛ in. (182 x 134 mm). M.729, fol. 16, detail.     175

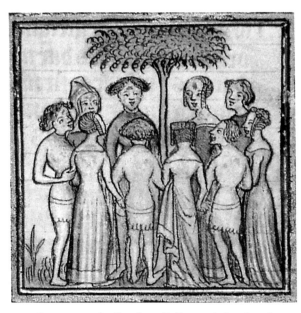

*Dancers around a Tree,* from Guillaume de Lorris and
Jean de Meun, *Roman de la rose,* c. 1380. Paris, France.
8 x 5½ in. (202 x 138 mm). M.132, fol. 7v, detail.

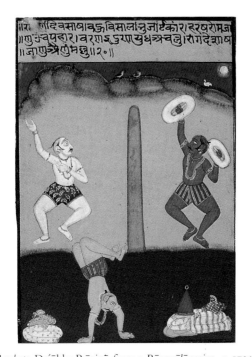

*Acrobats,* Deśākha Rāginī, from a *Rāgamālā* series, c. 1725.
Mewar school, Rajasthan, India.
Paper, 10⅝ x 8⅛ in. (270 x 206 mm). M.1049.1, detail.

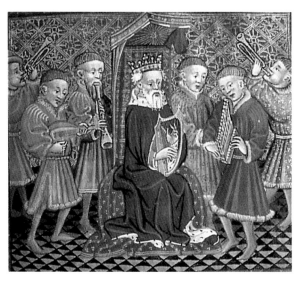

*King David and Musicians,* from *The Psalter and Book of Hours
of Henry Beauchamp, Duke of Warwick,*
1430s. London?, England.

178      10¾ x 7⅜ in. (271 x 186 mm). M.893, fol. 171, detail.

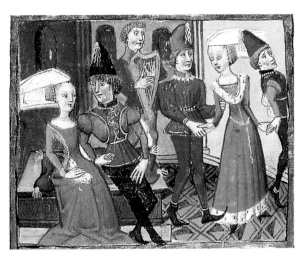

*Courtly Dancing,* from John Gower, *Confessio amantis,*
c. 1470. England. 17 x 12½ in. (440 x 320 mm).
M.126, fol. 179, left miniature, detail.

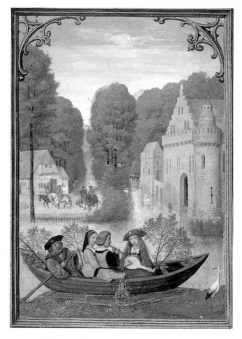

SIMON BENING (c. 1483–c. 1561).
*Boating Party with Music,* from *The Da Costa Hours,*
c. 1515. Bruges, Belgium.
6¾ x 4⅞ in. (172 x 125 mm). M.399, fol. 6v, detail.

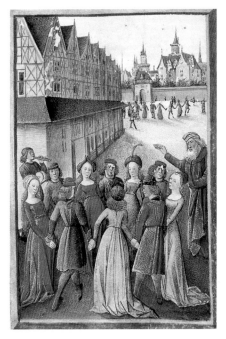

Jean Colombe (doc. 1463–93).
*City Youths Dancing*, from *The Hours of Anne de France*, c. 1473.
Bourges, France. 5¾ x 4¼ in. (150 x 110 mm).
M.677, fol. 137, detail.

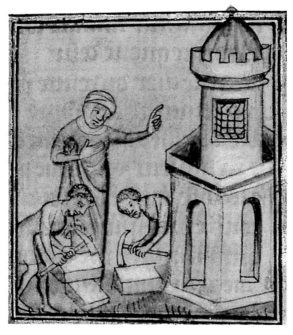

*Quarriers Preparing Stone Blocks,*
from Guillaume de Lorris and Jean de Meun,
*Roman de la rose,* c. 1380. Paris, France.
8 x 5½ in. (202 x 138 mm). M.132, fol. 32v, detail.

*Nimrod Building the Tower of Babel,*
from *Universal Chronicle,* c. 1360.
Regensburg?, Germany.
13½ x 9½ in. (343 x 242 mm). M.769, fol. 28v, detail.     183

*Tower Scriptorium of San Salvador de Tábara,*
from Beatus of Liébana, *Commentary on the Apocalypse,*
1220. Burgos?, Spain.

20½ x 14¼ in. (520 x 370 mm). M.429, fol. 183.

*Four Charitable Professions,* from Hugo von Trimberg,
*Der Renner,* c. 1460. Bavaria?, Germany.
Paper, 10⅝ x 8⅛ in. (293 x 207 mm). M.763, fol. 242.

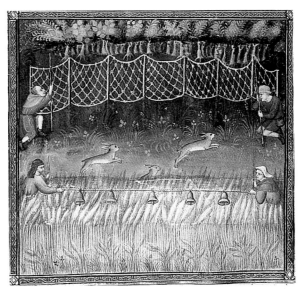

*Snaring Rabbits with Bells and Nets,* from Gaston Phébus, *Livre de la chasse,* c. 1410. Paris, France. 15⅛ x 11¼ in. (385 x 287 mm). M.1044, fol. 108, detail.

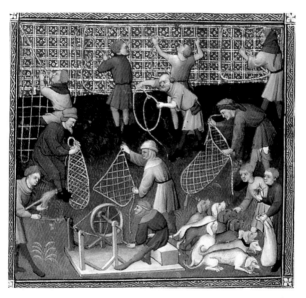

*Making Snares and Feeding Dogs,* from Gaston Phébus,
*Livre de la chasse,* c. 1410. Paris, France.
15⅛ x 11¼ in. (385 x 287 mm). M.1044, fol. 45, detail.

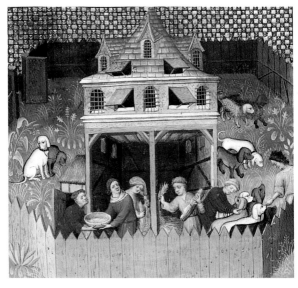

*Doghouse,* from Gaston Phébus, *Livre de la chasse,*
c. 1410. Paris, France.
15⅛ x 11¼ in. (385 x 287 mm). M.1044, fol. 43v, detail.

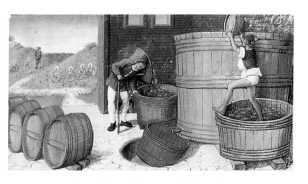

JEAN POYET (act. c. 1465–?1503).
*Wine-treaders,* from *The Hours of Henry VIII,*
c. 1500. Tours, France.
10⅛ x 7⅛ in. (256 x 180 mm). H.8, fol. 5, detail.

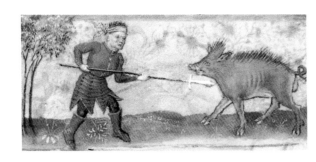

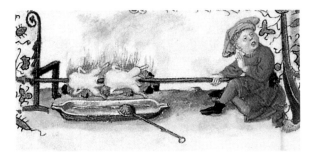

MASTER OF CATHERINE OF CLEVES (act. c. 1430–60).
*Boar Hunting* and *Roasting Spitted Fowl,* from
*The Hours of Catherine of Cleves,* c. 1440. Utrecht, Netherlands.
190  7½ x 5 in. (192 x 130 mm). M.917, p. 271 and p. 101, details.

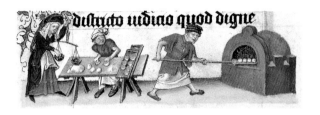

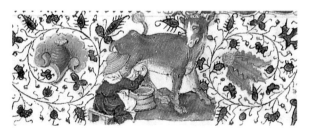

MASTER OF CATHERINE OF CLEVES (act. c. 1430–60).
*Baking* and *Woman Milking a Cow*, from *The Hours of Catherine of Cleves*, c. 1440. Utrecht, Netherlands.
7½ x 5 in. (192 x 130 mm). M.917, p. 226 and p. 91, details. 191

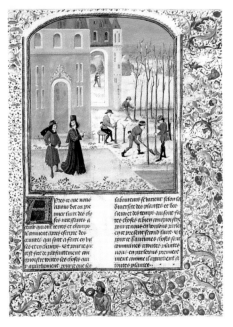

MASTER OF MARGARET OF YORK (act. c. 1470–75).
*Tree Planting and Grafting,* from Petrus Crescentius,
*Livre des prouffis champestres et ruraux,*
c. 1470. Bruges, Belgium.
16⅝ x 12¾ in. (428 x 335 mm). M.232, fol. 27, detail.

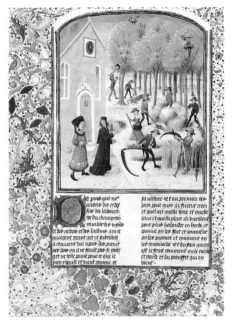

MASTER OF MARGARET OF YORK (act. c. 1470–75).
*Work in the Forests and Fields,* from Petrus Crescentius, *Livre des prouffis champestres et ruraux,* c. 1470. Bruges, Belgium.
16⅝ x 12¾ in. (428 x 335 mm). M.232, fol. 201v, detail.

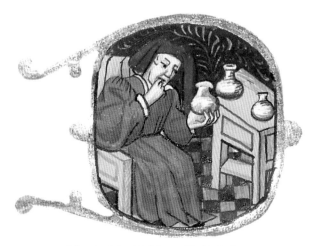

*Man Applying Medicine to His Teeth,* from
Aldobrandino da Siena, *Régime du corps,* c. 1430.
France. 10¼ x 7⅛ in. (260 x 185 mm). M.165, fol. 54v, detail.

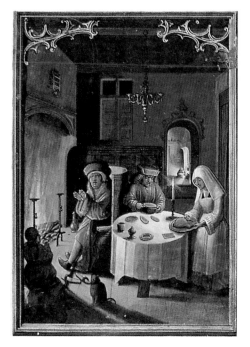

SIMON BENING (c. 1483–c. 1561).
*Dining,* from *The Da Costa Hours,* c. 1515. Bruges, Belgium.
6¾ x 4⅞ in. (172 x 125 mm). M.399, fol. 2v, detail.

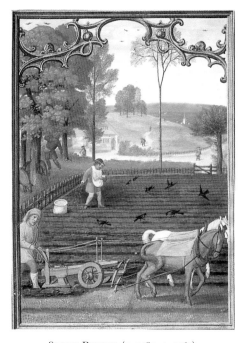

SIMON BENING (c. 1483–c. 1561).
*Plowing and Sowing,* from *The Da Costa Hours,*
c. 1515. Bruges, Belgium.
6¾ x 4⅞ in. (172 x 125 mm). M.399, fol. 10v, detail.

196

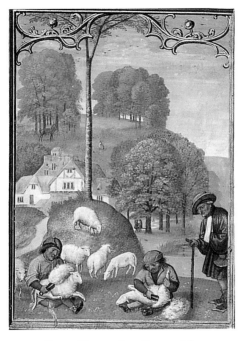

SIMON BENING (c. 1483–c. 1561).
*Shearing Sheep,* from *The Da Costa Hours,*
c. 1515. Bruges, Belgium.
6¾ x 4⅞ in. (172 x 125 mm). M.399, fol. 7v, detail.          197

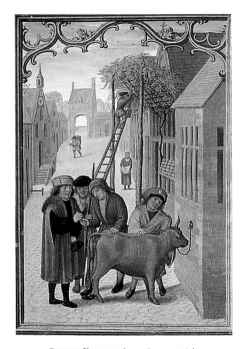

SIMON BENING (c. 1483–c. 1561).
*Buying the Bull,* from *The Da Costa Hours,*
c. 1515. Bruges, Belgium.
6¾ x 4⅞ in. (172 x 125 mm). M.399, fol. 11v, detail.

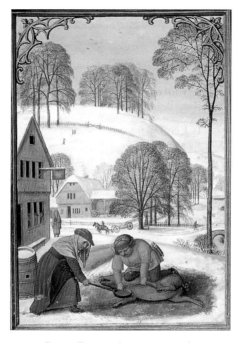

SIMON BENING (c. 1483–c. 1561).
*Slaughtering a Pig,* from *The Da Costa Hours,*
c. 1515. Bruges, Belgium.
6¾ x 4⅞ in. (172 x 125 mm). M.399, fol. 13v, detail.

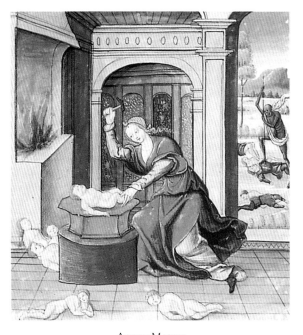

ACARIE MASTER.
*Mother Nature Forging Children,* from Guillaume de Lorris and
Jean de Meun, *Roman de la rose,* c. 1525. Rouen, France.
10⁵⁄₁₆ x 7⁵⁄₁₆ in. (262 x 186 mm). M.948, fol. 156, detail.

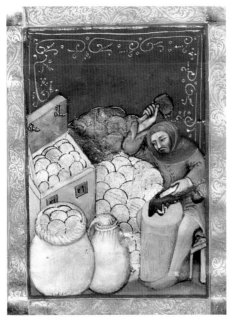

NICCOLÒ DA BOLOGNA (c. 1330–c. 1402).
*Goldbeater,* from Leaf from a Register of Creditors of a
Bolognese Lending Society, c. 1390s.
Bologna, Italy. 11⅝ x 12½ in.(295 x 319 mm).
M.1056v, detail.                                    201

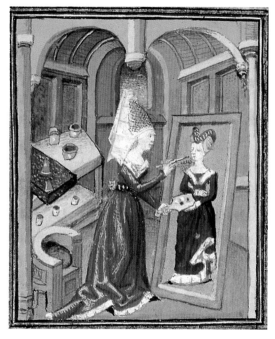

FOLLOWER OF THE BEDFORD MASTER.
*Timarete Painting a Portrait of Diana,* from Boccaccio,
*On Famous Women,* c. 1460. Loire region, France.
12⅞ x 9¼ in. (330 x 240 mm). M.381, fol. 33v, detail.

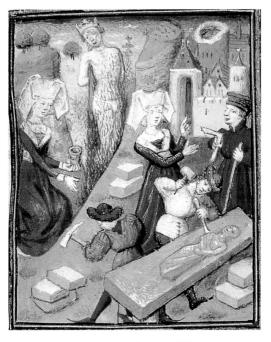

FOLLOWER OF THE BEDFORD MASTER.
*Artemisia Directing Work on Mausoleum and Cremating Mausolus,*
from Boccaccio, *On Famous Women,* c. 1460. Loire region,
France. 12⅞ x 9¼ in. (330 x 240 mm). M.381, fol. 34, detail.   203

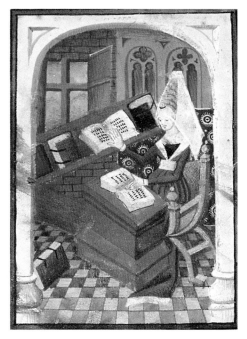

FOLLOWER OF THE BEDFORD MASTER.
*Falconia Proba Comparing Texts,* from Boccaccio,
*On Famous Women,* c. 1460. Loire region, France.
12⅞ x 9¼ in. (330 x 240 mm). M.381, fol. 60, detail.

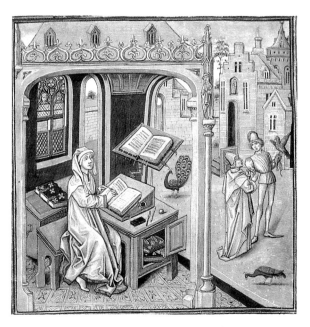

LOYSET LIÉDET (act. c. 1461–78).
*Jean de Vignay Translating the Text,* from Jacobus de Voragine,
*The Golden Legend,* 1460s. Bruges, Belgium.
15 x 10⅝ in. (379 x 270 mm). M.672, fol. 1, detail.

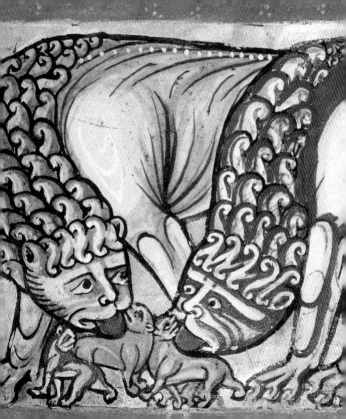

# FLORA AND FAUNA

Various types of manuscripts document the growing human awareness of and interest in the surrounding natural world. Herbals and other scientific treatises described the culinary and medical uses and benefits of the different parts of plants. In some illustrations, leaves, stem, flowers, and roots are so meticulously and faithfully rendered that they can easily be identified and linked to present-day equivalents. In other contexts, particularly Books of Hours, depictions of flowers and fruit served primarily ornamental functions. Surrounding a miniature or a block of text, this decoration enriches the beauty and costliness of a manuscript while astonishing viewers with authentic details such as dewdrops on leaves and caterpillars that wander over stems and foliage (pages 210–11).

In the Middle Ages, hunting, an occupation considered both a sport and a livelihood, was raised to a fine science. Books on the hunt provided information about the habits and behavior of wild animals, and described the strategies, techniques, and equipment used in their capture. Some of these books are lavishly illustrated, having been made for wealthy patrons. Game animals are pictured in typical activities and habitats, as are the animals used in their pursuit (pages 228–31). Hunting dogs were

highly prized by their owners, and much attention was devoted to their care and training. Luxurious dog houses were created for their comfort, and special attendants fed, exercised, and brushed the animals daily (see page 188). A variety of ingenious devices was used to trap the different game, according to size, strength, and levels of intelligence; smaller species could be driven to and entangled in finely woven snares (see page 186).

Books of fables became very popular in the medieval period, and were often illustrated. In these moralizing tales animals take human roles and either caricature human behavior or provide sensible solutions to ethical problems (pages 220–21). Another type of animal text, the Bestiary, evolved from Greek and Latin manuscripts of the pseudo-scientific *Physiologus*, a kind of encyclopedia that used descriptions of real and imaginary animals to illustrate Christian doctrines and morals. For example, legend has it that when a lioness gives birth the cubs lie dead for three days, but on the third day the father comes and breathes life into them. A parallel is made between this story and the Resurrection of Christ on the third day after his Crucifixion (pages 206 and 219). In early medieval illustrations animals are arranged in graceful if physically improbable poses and rendered in decorative colors and patterns. Later versions of this kind of work adopted a more naturalistic approach, and often the sensitivity and accuracy of physio-

logical details suggest direct observation by the artist (page 224). Other descriptive touches, however, seem calculated more to amuse than to instruct: one artist sought to convey the agility and playfulness of mountain goats by depicting one that nonchalantly leaps from a cliff and lands on its horns (page 225)!

As medieval stylistic conventions yielded to the awakening perceptions and visual theories that heralded the Renaissance, artists began to abandon the traditional backgrounds of gold leaf or decorative patterning. They employed the new science of perspective to create an illusion of three-dimensional space, where animals and figures interacted convincingly in a naturalistic setting. Atmospheric effects helped establish the feeling of depth: skies that lightened at the horizon line, and objects that diminished in size and became less distinct as they receded into the distance. Pictorial devices such as frames, sometimes elaborate architectural constructions, isolated and transformed miniatures into windows that opened into another world (pages 214–15). And while up to now nature had served primarily as a backdrop for the exploits and activities of human beings, around this time the beauties of natural phenomena began to be perceived and appreciated, and landscape represented for its own sake.

JEAN BOURDICHON (1457–1521).
*Cherries and Insects,* from Book of Hours, c. 1515. Tours,
France. 12 x 7⅝ in. (302 x 200 mm). M.732, fol. 42, detail.

JEAN BOURDICHON (1457–1521).
*Cucumbers,* from Book of Hours, c. 1515. Tours, France.
12 x 7⅝ in. (302 x 200 mm). M.732, fol. 47, detail.

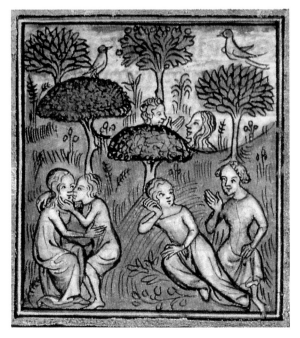

*Lovers in the Fields,* from Guillaume de Lorris and
Jean de Meun, *Roman de la rose,* c. 1380. Paris, France.
8 x 5½ in. (202 x 138 mm). M.132, fol. 59, detail.

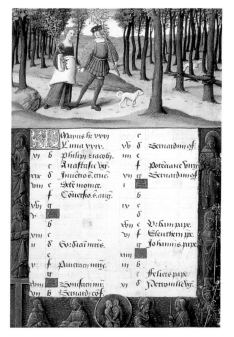

JEAN POYET (act. c. 1465–?1503).
*Strolling in the Countryside,* from *The Hours of Henry VIII,*
c. 1500. Tours, France. 10 x 7¼ in. (256 x 180 mm).
H.8, fol. 3, detail.

213

MASTER OF CHARLES V (act. c. 1505–33).
*Landscape with St. Anthony,* from Book of Hours, 1533.
Brussels?, Belgium. 5⅝ x 3⅛ in. (143 x 80 mm).
214                           M.491, fol. 59v.

Vu Soleil dans son midi qui repend ses
influences sur la terre.

OMNIA OMNIBVS

Par une feconde influence .
Il donne l'être & la naissance .
Il éleve , il échaufe , il conserve , il nourrit
Mais quoique , de tout il dispose .
Et qu'il soit tout en toute chose .
Il ne change jamais l'ordre qu'il s'est preferit .

*Christ, the True Son, Shines on Wheat and Vineyards,*
from *Manna, Emblem of the Sacred Eucharist,*
*and Three Other Treatises,* 1679. Paris, France.
15⅜ x 10¼ in. (392 x 262 mm). M.21, fol. 146, detail.

215

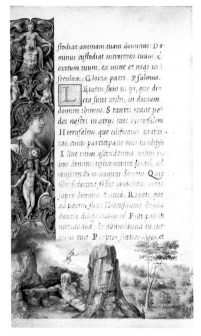

GIULIO CLOVIO (1498–1578).
*Landscape*, from *The Farnese Hours*, 1546.
Rome, Italy. 6¾ x 4¼ in. (173 x 110 mm), each page.
M.69, fols. 32v–33.

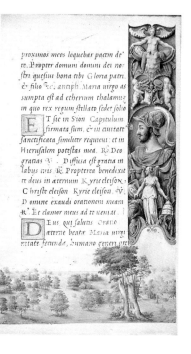

proximos meos loquebar pacem de
te. Propter domum domini dei no-
stri quesiui bona tibi Gloria patri.
& filio &c. antiph. Maria uirgo as
sumpta est ad etherium thalamum
in quo rex regum stellato sedet solio

ET sic in Sion Capitulum
firmata sum, & in ciuitate
sanctificata similiter requieui : et in
Hierusalem potestas mea. R̊ Deo
gratias V̊ . Diffusa est gratia in
labijs tuis. R̊. Propterea benedixit
te deus in æternum Kyrie eleison.
Christe eleison Kyrie eleison. V̊.
Domine exaudi orationem meam
R̊. Et clamor meus ad te ueniat. t.

DEus qui salutis oratio
æterne beatæ Mariæ uirgi-
nitate fecunda, humano generi præ

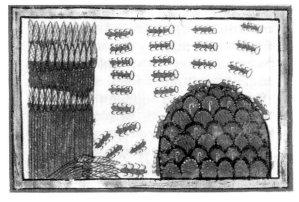

*Ants,* from *The Worksop Bestiary,* before 1187.
Lincoln?, England.
8½ x 6⅛ in. (215 x 155 mm). M.81, fol. 31v, detail.

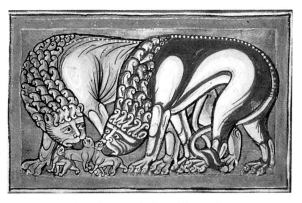

*Lions Breathe Life into Cubs,* from *The Worksop Bestiary,*
before 1187. Lincoln?, England.
8½ x 6⅛ in. (215 x 155 mm). M.81, fol. 8, detail.

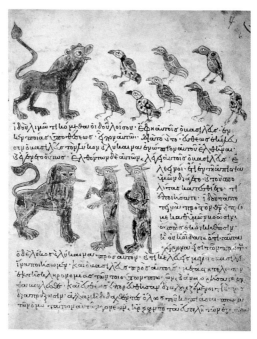

*Birds Complain to Azachar that Wolves Eat All the Figs; Azachar Warns Two Wolves,* from *Fables of Bidpai, and Other Texts,* 10th or 11th century. Southern Italy.

220

8½ x 6⅝ in. (215 x 166 mm). M.397, fol. 6.

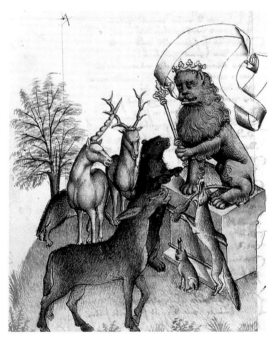

*Lion Addresses the Other Beasts,* from Hugo von Trimberg,
*Der Renner,* c. 1460. Bavaria?, Germany.
Paper, 10⅝ x 8⅛ in. (293 x 207 mm).
M.763, fol. 29v.

*Two Foxes,* from Ibn Bakhtīshū',
*Benefits of Animals,* late 1290s. Maragha, Persia.
Paper, 13⅜ x 9⅝ in. (335 x 250 mm). M.500, fol. 23, detail.

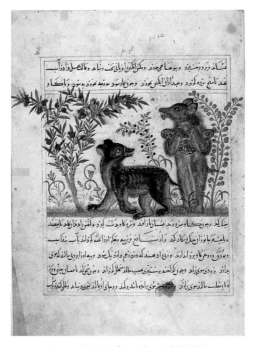

*Bears and Cubs,* from Ibn Bakhtīshū',
*Benefits of Animals,* late 1290s. Maragha, Persia.
Paper, 13⅜ x 9⅝ in (335 x 250 mm). M.500, fol. 24.

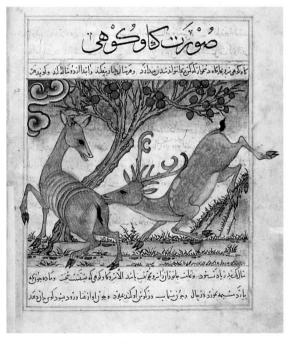

*Spotted Doe and Deer,* from Ibn Bakhtīshūʻ,
*Benefits of Animals,* late 1290s. Maragha, Persia.
Paper, 13⅜ x 9⅝ in. (335 x 250 mm). M.500, fol. 33v.

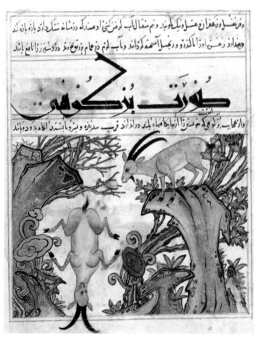

*Mountain Goats,* from Ibn Bakhtīshū',
*Benefits of Animals,* late 1290s. Maragha, Persia.
Paper, 13⅜ x 9⅝ in. (335 x 250 mm). M.500, fol. 37v.

*Simurgh,* from Ibn Bakhtīshū',
*Benefits of Animals,* late 1290s. Maragha, Persia.
Paper, 13⅜ x 9⅝ in. (335 x 250 mm). M.500, fol. 55, detail.

226

*Ostriches,* from Ibn Bakhtīshū',
*Benefits of Animals,* late 1290s. Maragha, Persia.
Paper, 13⅜ x 9⅝ in. (335 x 250 mm). M.500, fol. 62v, detail.

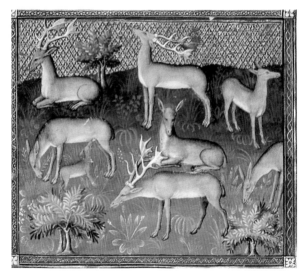

*Fallow Deer,* from Gaston Phébus,
*Livre de la chasse,* c. 1410. Paris, France.
15⅛ x 11¼ in. (385 x 287 mm). M.1044, fol. 11, detail.

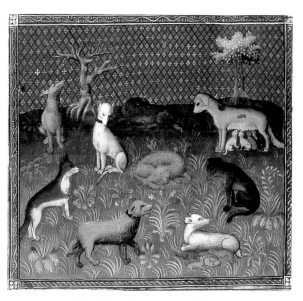

*Watchdogs,* from Gaston Phébus,
*Livre de la chasse,* c. 1410. Paris, France.
15⅛ x 11¼ in. (385 x 287 mm). M.1044, fol. 42, detail.

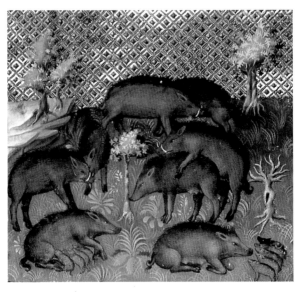

*Wild Boars,* from Gaston Phébus,
*Livre de la chasse,* c. 1410. Paris, France.
15⅛ x 11¼ in. (385 x 287 mm). M.1044, fol. 20v, detail.

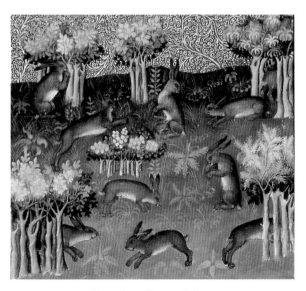

*Hares,* from Gaston Phébus,
*Livre de la chasse,* c. 1410. Paris, France.
15⅛ x 11¼ in. (385 x 287 mm). M.1044, fol. 15v, detail.

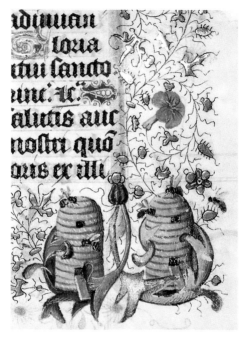

MASTER OF CATHERINE OF CLEVES (act. c. 1430–60).
*Bees and Beehives,* from *The Hours of Catherine of Cleves,* c. 1440.
Utrecht, Netherlands. 7½ x 5 in. (192 x 130 mm).
M.945, fol. 20, detail.

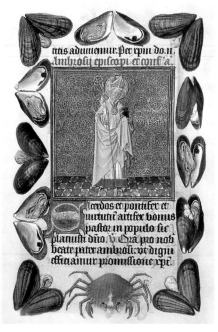

MASTER OF CATHERINE OF CLEVES (act. c. 1430–60).
*Crab and Mussels Surrounding St. Ambrose,* from
*The Hours of Catherine of Cleves,* c. 1440. Utrecht, Netherlands.
7½ x 5 in. (192 x 130 mm). M.917, p. 244.

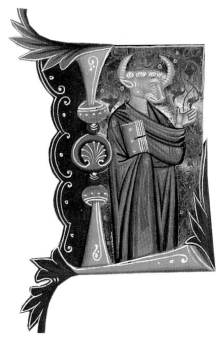

*Saint Luke with Head of Ox*, from Bible,
c. 1300. Padua, Italy.
16¾ x 10½ in. (425 x 265 mm). M.436, fol. 362v, detail.

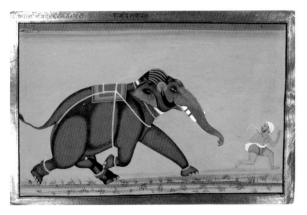

*The Elephant Dalbadal Chasing His Trainer,*
c. 1750. Mewar school, Rajasthan, India.
Paper, 12½ x 19⅛ in. (317 x 485 mm). M.1006.

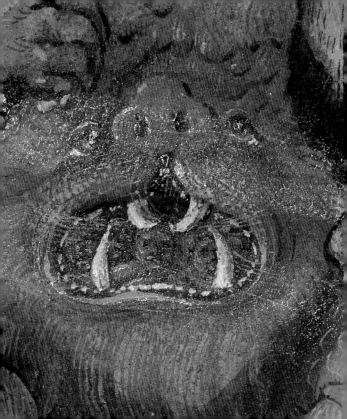

# THE SUPERNATURAL

Superstition, fantasy, and the supernatural played important roles in the medieval world, underlying the realities of everyday living. The calendars that open Books of Hours are often illustrated with the labors of the month paired with the signs of the zodiac (pages 256–59). The stars were believed to affect human activities, and following pioneering work in early Mesopotamia and Egypt astronomy and astrology were studied in the twelfth century by Arabic scholars. A specific sign of the zodiac was said to govern each individual's fortune, and astrological charts were consulted for the treatment of illness and to establish the most propitious moment for business and other important transactions. The mythological figures associated with medieval and Renaissance representations of the constellations and the signs of the zodiac derive from classical antiquity, at which time they appeared in manuscripts, mosaics, and wall paintings, and in three-dimensional sculptures. Renaissance versions of the zodiacal signs betray a revival of classical form, manifested by the careful modeling of bodies and the use of proportions and poses seen on Greek and Roman statues (pages 254-55). The ancient stories of gods and goddesses also became popular with medieval audiences. In secular literature,

books like the *Roman de la rose* incorporated mythological tales in allegorical fashion, giving artists further opportunities to demonstrate their skill at rendering the human body naturalistically.

While the stars were consulted on matters of business and health, they were ineffectual in assuaging the greatest medieval preoccupations that centered on death and the fate of the soul. In addition to representations of funeral and burial rituals (pages 272–73), death itself was personified in dramatic and gruesome compositions, generally in the form of a skeleton or eviscerated corpse, and with an air of lying in wait for or triumphing over its victims (pages 261, 275, and 276–77). Death appeared when least expected, and respected neither tender age nor circumstance (page 270). And after burial, unpleasant experiences would transpire for the wicked or the unrepentant. The repulsive aliens in today's science fiction films have no edge over the monsters and demons imagined by the medieval mind, always at hand and ready to recruit souls to the realms of the damned (pages 236, 263, and 269). The door to Hell was envisioned as a hideous fanged mouth, guarded by the terrifying servants of the devil, who would pull in their quarry with sharp hooked tools, slated for an eternity of torture and deprivation (pages 266 and 268).

But medieval life was not completely grim and ghoulish. The pages of manuscripts testify to a wide range

of medieval humor, from the subtle and wry to the sarcastic and profane. An important facet of this humor is the inversion of reality into a contrasting topsy-turvy world where opposites reign. Here the hunter and the hunted exchange roles (page 243), and animals perform human tasks. Human heads sprout from animal bodies or vinestems (page 248); detached body parts take on lives of their own (page 240); animal and vegetable components elongate, intertwine, and form rhythmic patterns around the text. Nothing is sacred: even a tonsured head is displaced to an indelicate location and paid false obeisance by a Knight Templar (page 241).

Some of these creations may exercise a moral function, embodying Christian beliefs about sin, or provide critical comment, perhaps contempt or ridicule, on the text. But most of them were probably aimed at amusing the reader, providing a comic-book-like subtext that could have lightened the study of long didactic tomes, or simply provoked a belly laugh in the midst of sober moralizing essays or terrifying sermons. A dose of humor would distract from daily hardships and fears of the afterlife. And there was also hope of Heaven for those who truly repented or lived pious lives: a glorious country filled with light and fleecy clouds, and the company of angels and saints.

*Body Hide and Seek,* from Book of Hours, c. 1320s.
Thérouanne, France.
6 x 4¼ in. (156 x 111 mm). M.754, fol. 89.

*Knight Templar Kissing a Cleric's Bum,* from Jacques
de Longuyon, *Voeux du paon,* c. 1350. Tournai?, Belgium.
9⅝ x 7 in. (245 x 179 mm). G.24, fol. 70, detail.

*Fox Carrying Trussed Hare,* from *Registrum brevium,*
late 13th–early 14th century. England.
8⅜ x 6 in. (214 x 154 mm). M.812, fol. 24, detail.

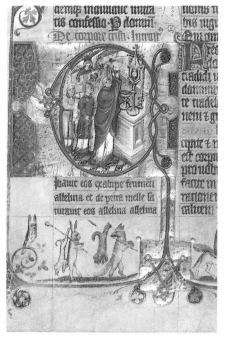

STYLE OF MASTER BERTRAM OF MINDEN (c. 1340–1414).
*Priest Elevates the Host; Rabbit and Fox Carry Dogs,*
from Missal leaf, before 1381. Hamburg, Germany.
15½ x 11¼ in. (398 x 290 mm). M.892.2, detail.

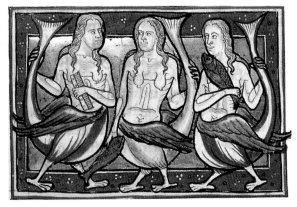

*Sirens,* from *The Worksop Bestiary,* before 1187.
Lincoln?, England.
8½ x 6⅛ in. (215 x 155 mm). M.81, fol. 17, detail.

JACOB ELSNER (act. c. 1486–1517).
*Wild Woman Rescuing Child from Dragon,* from Gradual
*(The Geese Book),* 1510. Nuremberg, Germany.
25¾ x 17¼ in. (654 x 438 mm). M.905, vol. II, fol. 122, detail. 245

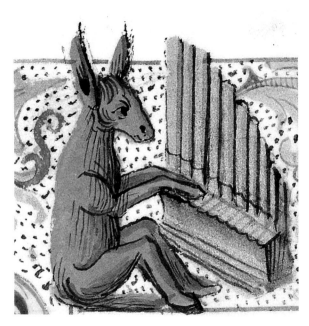

*Donkey Playing a Portative Organ,* from Breviary,
c. 1490. Toulouse?, France.
11¾ x 7¾ in. (300 x 196 mm). M.463, fol. 145, detail.

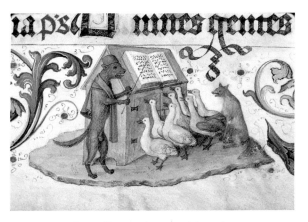

JACOB ELSNER (act. c. 1486–1517).
*Fox Conducts Choir of Geese,* from Gradual *(The Geese Book),*
1507. Nuremberg, Germany.
25¾ x 17½ in. (654 x 445 mm). M.905, vol. I, fol. 186, detail.  247

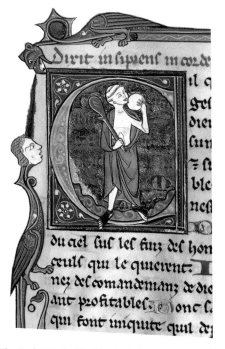

*The Fool, Watched by Marginal Creature,* from Bible,
third quarter 13th century. Paris, France.
15¼ x 11 in. (390 x 285 mm). M.494, fol. 308, detail.

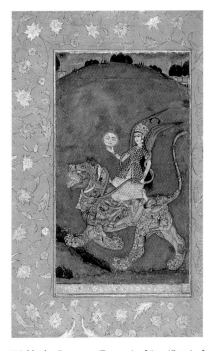

*Peri Holds the Sun on a Composite Lion (Sun in Leo)*,
third quarter 18th century. Kashmir, India.
Paper, 13½ x 8¾ in. (343 x 222 mm). M.787, detail.

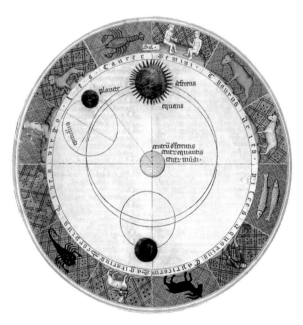

*Zodiac and Planets Circling Earth,* from Sacrobosco,
*Sphaera mundi,* 1st quarter 15th century. Austria.
12 x 9¼ in. (305 x 235 mm). M.722, fol. 18, detail.

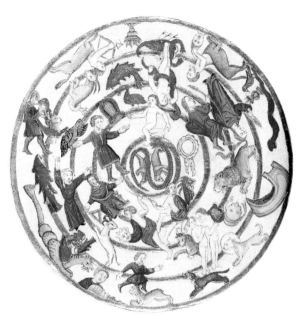

MASTER OF ISABELLE DI CHIAROMONTE (act. 1450s–60s).
*Planisphere with Constellations,* from Aratus, *Phaenomena,* 1469.
Naples, Italy. 8⅜ x 5½ in. (214 x 140 mm).
M.389, fol. 3v, detail.

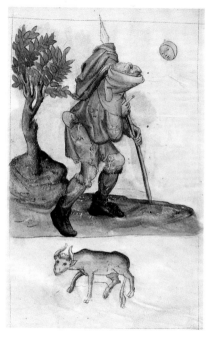

*Luna in Exaltation; Taurus,* from Albumasar,
*Astrological Treatises,* c. 1403. Bruges, Belgium.
9⅝ x 7 in. (245 x 179 mm). M.785, fol. 50v.

MASTER OF ISABELLE DI CHIAROMONTE (act. 1450s–60s).
*Serpentarius on Scorpio,* from Aratus, *Phaenomena,* 1469.
Naples, Italy. 8⅜ x 5½ in. (214 x 140 mm).
M.389, fol. 16v, detail.

253

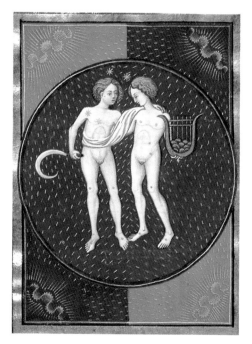

VENTURINO MERCATI? (act. c. 1460s–80s).
*Gemini,* from Book of Hours,
c. 1470. Milan?, Italy.

254     5⅝ x 4⅜ in. (142 x 110 mm). G.14, fol. 7v, detail.

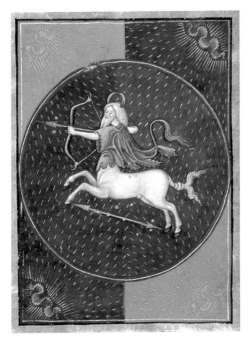

VENTURINO MERCATI? (act. c. 1460s–80s).
*Sagittarius,* from Book of Hours,
c. 1470. Milan?, Italy.
5⅝ x 4⅜ in. (142 x 110 mm). G.14, fol. 16v, detail.  255

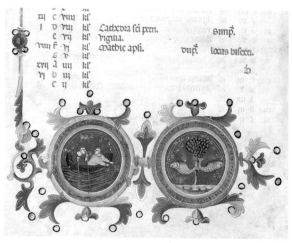

Master of B18 (the second master of the Choirbook
of San Domenico, Bologna) (act. 1320s–30s).
*Fishing and Pisces,* from Calendar, c. 1324–28.
Bologna, Italy. 13½ x 9 in. (350 x 230 mm).
M.511, fol. 1v, detail.

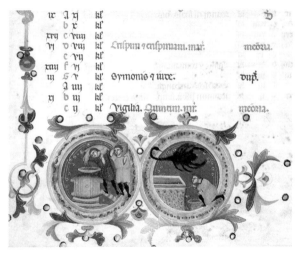

MASTER OF B18 (THE SECOND MASTER OF THE CHOIRBOOK
OF SAN DOMENICO, BOLOGNA) (act. 1320s–30s).
*Filling Casks, Drawing Wine, and Scorpio,* from Calendar,
c. 1324–28. Bologna, Italy.
13½ x 9 in. (350 x 230 mm). M.511, fol. 5v, detail.     257

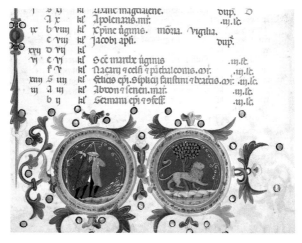

MASTER OF B18 (THE SECOND MASTER OF THE CHOIRBOOK
OF SAN DOMENICO, BOLOGNA) (act. 1320s–1330s).
*Threshing and Leo,* from Calendar,
c. 1324–28. Bologna, Italy.

13½ x 9 in. (350 x 230 mm). M.511, fol. 4, detail.

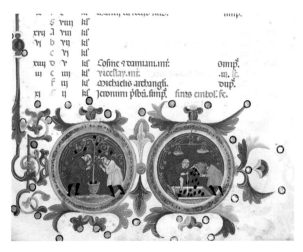

MASTER OF B18 (THE SECOND MASTER OF THE CHOIRBOOK
OF SAN DOMENICO, BOLOGNA) (act. 1320s–30s).
*Harvesting, Pressing Grapes, and Libra,* from Calendar,
c. 1324-28. Bologna, Italy.
13½ x 9 in. (350 x 230 mm). M.511, fol. 5, detail.

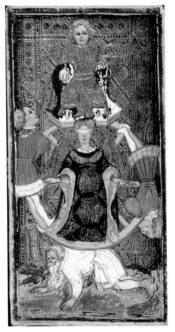

Bonifacio Bembo (act. 1440–80) or Francesco Zavattari (act. 1417–83). *Wheel of Fortune*, from Visconti-Sforza Tarot Cards, c. 1450. Milan, Italy.
6⅞ x 3⅜ in. (175 x 87 mm). M.630.9.

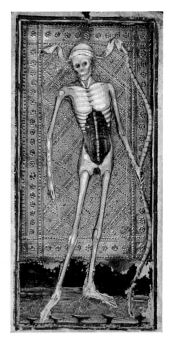

BONIFACIO BEMBO (act. 1440–80) or FRANCESCO ZAVATTARI
(act. 1417–83). *Death,* from Visconti-Sforza Tarot Cards,
c. 1450. Milan, Italy.
6⅞ x 3⅜ in. (175 x 87 mm). M.630.12.

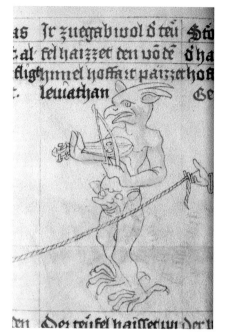

*The Devil Leviathan Playing a Rebec,* from
Ulrich von Lilienfeld, *Concordantiae caritatis,* 1470s.
Vienna, Austria.

13¾ x 10½ in. (350 x 265 mm). M.1045, fol. 256v, detail.

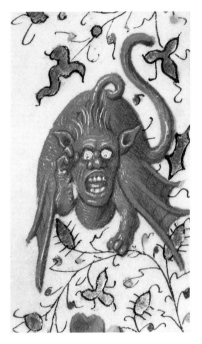

MASTER OF CATHERINE OF CLEVES (act. c. 1430–60).
*Demon*, from *The Hours of Catherine of Cleves*,
c. 1440. Utrecht, Netherlands.
7½ x 5 in. (192 x 130 mm). M.945, fol. 60v, detail. 263

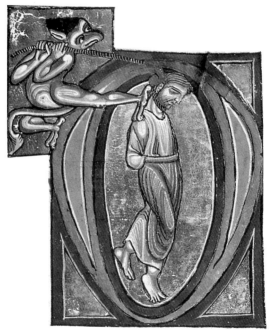

MASTER OF THE BERTHOLD SACRAMENTARY.
*A Demon Garrots Judas,* from *The Berthold Sacramentary,*
c. 1215–17. Weingarten Abbey, Germany.
11½ x 8 in. (293 x 204 mm). M.710, fol. 40, detail.

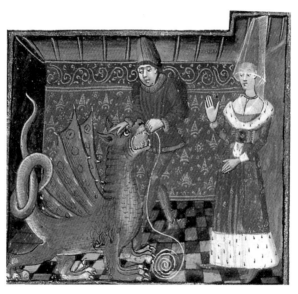

*Theseus and Ariadne with Demon,* from John Gower,
*Confessio amantis,* c. 1470. England.
17 x 12½ in. (440 x 320 mm). M.126, fol. 120, detail.

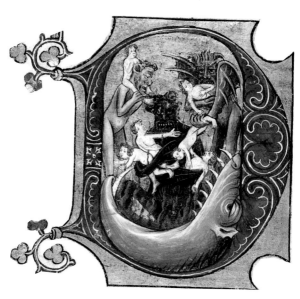

MASTERS OF DIRC VAN DELF (act. c. 1400–1410).
*Hellmouth,* from Dirc van Delf, *The Table of Christian Faith,*
c. 1405–10. Utrecht, Netherlands.
8⅝ x 6⅛ in. (215 x 153 mm). M.691, fol. 200v, detail.

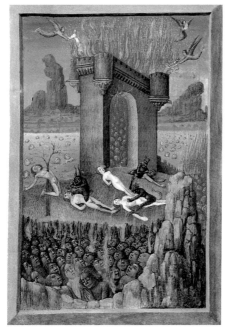

JEAN COLOMBE (doc. 1463–93).
*Hell,* from *The Hours of Anne de France,* c. 1473. Bourges, France.
5¾ x 4¼ in. (150 x 110 mm). M.677, fol. 250v, detail.

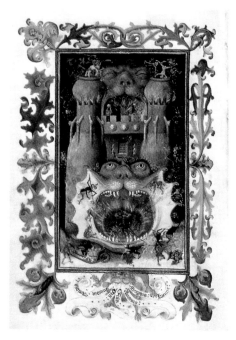

MASTER OF CATHERINE OF CLEVES (act. c. 1430–60).
*Hellmouth,* from *The Hours of Catherine of Cleves,*
c. 1440. Utrecht, Netherlands.

7½ x 5 in. (192 x 130 mm). M.945, fol. 168v.

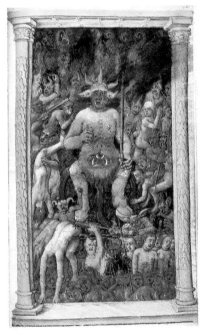

MASTER OF PETRARCH'S TRIUMPHS (act. 1480s–1510s).
*Satan and the Damned in Hell,*
from *The Hours of Claude Molé,* c. 1500. Paris, France.
8¾ x 4⅛ in. (172 x 110 mm). M.356, fol. 64.

269

BEDFORD MASTER AND WORKSHOP (act. 1430s–40s).
*Death Takes a Child,* from Book of Hours,
c. 1430–35. Paris, France.
270    10 x 6⅞ in. (255 x 173 mm). M.359, fol. 151, detail.

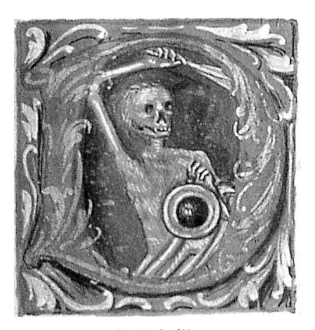

*Death with a Mirror,* from Book of Hours, c. 1490–1500.
Cambrai or Mons, Belgium.
5¼ x 3¾ in. (134 x 95 mm). M.33, fol. 181, detail.

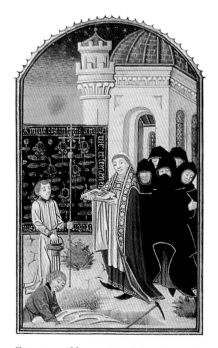

GUILLAUME HUGUENIOT (act. 1460s–70s).
*Burial*, from *The Hours of Pierre de Bosredont,*
c. 1465. Langres, France.

6⅛ x 4⅜ in. (156 x 112 mm). G.55, fol. 89v, detail.

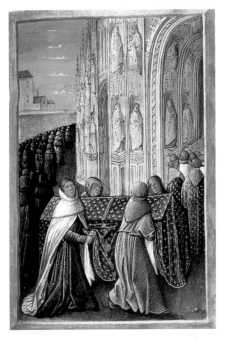

JEAN COLOMBE (doc. 1463–93).
*Funeral Procession*, from *The Hours of Anne de France*,
c. 1473. Bourges, France.
5¾ x 4¼ in. (150 x 110 mm). M.677, fol. 255, detail.

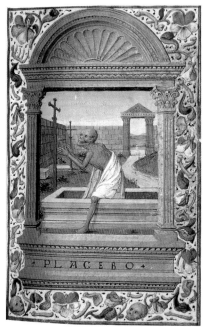

GEORGES TRUBERT (doc. 1467–c. 1499).
*Death Stepping from a Coffin,* from Book of Hours,
c. 1485–90. Avingnon, France.
5 x 3½ in. (126 x 85 mm). M.348, fol. 155.

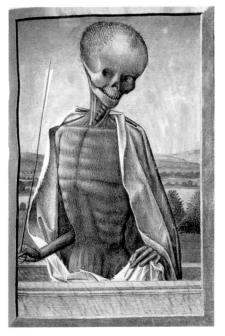

JEAN COLOMBE (doc. 1463–93).
*Death Holding an Arrow,* from *The Hours of Anne de France,*
c. 1473. Bourges, France.
5¾ x 4¼ in. (150 x 110 mm). M.677, fol. 245, detail.

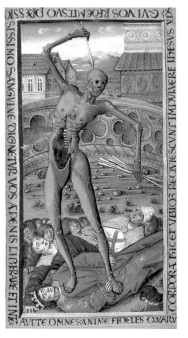

MASTER OF PETRARCH'S TRIUMPHS (act. 1490s–1510s).
*The Triumph of Death,*
from *The Hours of Claude Molé*, c. 1500.
276    Paris, France. 8¾ x 4⅛ in. (172 x 110 mm). M.356, fol. 63.

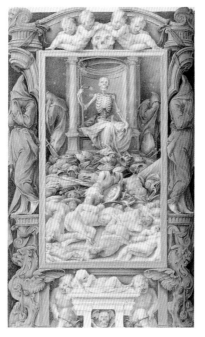

GIULIO CLOVIO (1498–1578).
*Triumph of Death,* from *The Farnese Hours,* 1546.
Rome, Italy. 6¾ x 4¼ in. (173 x 110 mm).
M.69, fol. 79v.

# Selected Bibliography

Alexander, J.J.G., ed. *The Painted Page: Italian Renaissance Book Illumination, 1450–1500*. New York: Prestel, 1994. Includes the best Morgan manuscripts and illuminated incunabula.

Alexander, J.J.G., et al. *A Survey of Manuscripts Illuminated in the British Isles*. 6 vols. to date. London: Harvey Miller, 1975–. Includes the Library's most important English manuscripts.

Cockerell, Sydney C., and John Plummer. *Old Testament Miniatures: A Medieval Picture Book with 283 Paintings from the Creation to the Story of David*. New York: George Braziller, 1975. [M.638]

Eisler, Colin. *The Prayer Book of Michelino da Besozzo*. New York: The Pierpont Morgan Library and George Braziller, 1981. [M.944]

Harrsen, Meta. *Central European Manuscripts in The Pierpont Morgan Library*. New York: The Pierpont Morgan Library, 1958.

——————. *Italian Manuscripts in The Pierpont Morgan Library*. New York: The Pierpont Morgan Library, 1953.

Marrow, James et al. *The Golden Age of Dutch Manuscript Painting*. New York: The Pierpont Morgan Library, 1990. Includes the Library's most important Dutch manuscripts.

Mathews, Thomas F., and Roger S. Wieck, eds. *Treasures in Heaven: Armenian Illuminated Manuscripts*. New York: The Pierpont Morgan Library, 1994.

The Pierpont Morgan Library. *In August Company: The Collections of The Pierpont Morgan Library*. New York: The Pierpont Morgan Library, 1993. A fine overview of the Library's complete holdings.

Plummer, John. *The Hours of Catherine of Cleves*. New York: George Braziller, 1966. [M.917 and M.945]

Plummer, John, assisted by Gregory Clark. *The Last Flowering: French Painting in Manuscripts 1420–1530, from American Collections*. New York: The Pierpont Morgan Library, 1982.

Smith, Webster. *The Farnese Hours: The Pierpont Morgan Library, New York*. New York: George Braziller, 1976. [M.69]

Vikan, Gary, ed. *Illuminated Greek Manuscripts from American Collections*. Princeton, N.J.: The Art Museum, Princeton University, 1973. Includes the Library's best Greek manuscripts.

Visconti Sforza Tarocchi Deck, with Instructions by Stuart R. Kaplan. Stamford, Connecticut: U.S. Games Systems, Inc., 1975.

Wieck, Roger S. *Painted Prayers: The Book of Hours in Medieval and Renaissance Art*. New York: George Braziller, 1997.

Williams, John. *The Illustrated Beatus: A Corpus of the Illustrations of the Commentary on the Apocalypse*. London: Harvey Miller, 1994–. The Library's three Beatus manuscripts (M.429, M.644, and M.1079) will appear in various volumes of the above.

Williams, John, and Barbara Shailor. *A Spanish Apocalypse: The Morgan Beatus Manuscript*. New York: George Braziller, in association with the Pierpont Morgan Library, 1991. [M.644]

# Index of Illustrations

Acarie Master, 148, 172, 200

Acrobats, 177

*Adoration of the Magi* (Poyet), 45

*Alexander the Great Visits King Dindimus*, 145

Alexis Master and Workshop, 122, 140

*Alfonso II of Aragon, King of Naples, and His Coronation Cortege*, 149

*All Martyrs* (Bening), 109

*Angels Holding Monstrance with Host* (Elsner), 134

*Anger* (Testard), 125

*Animals Leaving Noah's Ark*, 30

*Anjou Legendary, The*, 92–93

*Annunciation* (Bourdichon), 41

*Annunciation to the Shepherds*, 43

*Ants*, 218

*Apocalypse of Margaret of York, The*, 74–75

*Apocalypse Picture Book*, 80–81

*Archangel Gabriel*, 96

*Archangel Michael Weighing a Soul*, 97, 116

*Archer on an Aged Horse* (Style of Muhammad 'Alī ibn Malik Husain), 165

*Arma Christi* (Master of Guillebert de Mets), 133

*Artemisia Directing Work on Mausoleum and Cremating Mausolus* (Follower of the Bedford Master), 203

*Astrological Treatises* (Albumasar), 252

Attavante degli Attavanti, 131

*Avarice* (Testard), 126

*Avis aus Roys*, 142–44

*Baking* (Master of Catherine of Cleves), 191

*Baptism* (Masters of Dirc van Delf), 114

*Baptism of Christ* (Olivetan Master), 53

*Battle in Town Square of Jacointe* (Style of the Master of Champion des Dames), 155

*Battle of Ecluse* (Master of the Berry Apocalypse Workshop), 152

*Bears and Cubs*, 223

Bedford Master, Follower of the, 202–4

Bedford Master and Workshop, 270

*Bees and Beehives* (Master of Catherine of Cleves), 232

*Beheading of John the Baptist* (Late Follower of the Master of the Munich Golden Legend), 108

Bembo, Bonifacio, 260–61

*Benefits of Animals* (Ibn Bakhtīshū'), 222–27

Bening, Simon, 54, 109, 112–13, 162, 180, 195–99

*Berry Apocalypse, The*, 76–77

*Berthold Sacramentary, The*, 20, 44, 95, 264

*Betrothal of the Virgin* (Master of Morgan 453), 38–39

*Birds Complain to Azachar that Wolves Eat All the Figs; Azachar Warns Two Wolves*, 220

*Boar Hunting* (Master of Catherine of Cleves), 190

*Boating Party with Music* (Bening), 180

*Body Hide and Seek*, 240

*Book of Alexander*, 145

*Book of the Holy Hermeniae*, 46

Boucicaut Master and Workshop, 118

Bourdichon, Jean, 41, 210–11

*Breviary of Eleanor of Portugal, The*, 111

*Burial* (Hugueniot), 272

*Burial* (Master of Marguerite d'Orléans), 119

*Buying the Bull* (Bening), 198

*Celebration of Mass* (Master of 1328), 120

*Cherries and Insects* (Bourdichon), 210

*Christ, the True Son, Shines*

on Wheat and Vineyards, 215

Christ Ascending the Cross (Pacino da Bonaguida), 59

Chronicle of Flanders from 1420 to 1485, 157

Chronicle of Naples (Ferraiolo), 149

Chroniques (Jean Froissart), 152

Circumcision, 47

City Youths Dancing (Colombe), 181

Clovio, Giulio, 24–25, 32, 55, 61, 216–17, 277

Codrus Dies for His People in Single Combat, 151

Colombe, Jean, 29, 68, 181, 267, 273, 275

Commentary on Daniel (St. Jerome), 84

Commentary on the Apocalypse (Beatus of Liébana), 78–79, 82–83, 184

Concordantiae caritatis (Ulrich von Lilienfeld), 262

Confessio amantis (John Gower), 151, 179, 265

Coronation of David, 141

Coronation of the Virgin (Colombe), 68

Courtly Dancing, 179

Crab and Mussels Surrounding St. Ambrose (Master of Catherine of Cleves), 233

Creation (Clovio), 24

Creation of Fishes and Birds; Animals and Man; Creation of Eve and God's Warning; Fall of Man, 26–27

Crivelli, Taddeo, 132

Crucifixion (Clovio), 61

Crucifixion (Niccolò di Bologna), 62

Crucifixion (Poyet), 60

Cucumbers (Bourdichon), 211

Da Costa Hours, The, 54, 109, 162, 180, 195–99

Dancers around a Tree, 176

David, Gerard, 69

David Harping before Saul, 34

David Playing the Bells, 174

Death (Bembo or Zavattari), 261

Death Holding an Arrow (Colombe), 261

Death Stepping from a Coffin (Trubert), 274

Death Takes a Child (Bedford Master and Workshop), 270

Death with a Mirror, 271

De Bois Hours, The, 96–97

Decretals (Gregory IX), 120

Demon (Master of Catherine of Cleves), 263

Demon Garrots Judas, A (Master of the Berthold Sacramentary), 264

Destruction of Babylon (Maius), 79

Devil Leviathan Playing a Rebec, The, 262

Devil Tempts Eve, The (Ingeborg Psalter Workshop), 28

Diligence of Queens, The, 143

Dining (Bening), 195

Doghouse, 188

Donkey Playing a Portative Organ, 246

Dormition of the Virgin, 67

Dragon and the Beast, The (Master of the Moral Treatises), 75

Dream of Nebuchadnezzar (Maius), 84

Education of the Virgin (Poyet), 37

Egmont Breviary, The, 99

Elephant Dalbadal Chasing His Trainer, The, 235

Elsner, Jacob, 134, 245, 247

Entombment of the Virgin (Perhtolt), 66

Entry into Jerusalem, 56

Envy (Testard), 124

Equestrian Portrait of Charles of Burgundy (Master of the Bruges Chronicle of Flanders), 157

Eve Offers the Fruit to Adam (Colombe), 29

Fables of Bidpai, and Other Texts, 220

Falconia Proba Comparing Texts (Follower of the Bedford Master), 204

Fall of Man (Clovio), 25

Fallow Deer, 228

Farnese Hours, The, 24–25, 32, 55, 61, 216–17, 277

Filling Casks, Drawing Wine, and Scorpio (Master of B18), 257

Fishing and Pisces (Master of B18), 256

Flight into Egypt, 49

Fool, Watched by Marginal Creature, The, 248

Four Charitable Professions, 185

Four Horsemen and Serpent Tails, 78

Fox Carrying Trussed Hare, 242

Fox Conducts Choir of Geese (Elsner), 247

Francesco da Castello, 63

Francesco da Castello Workshop, 63

Funeral Procession (Colombe), 273

Funeral Service (Boucicaut Master and Workshop), 118

Geese Book, The, 134, 245, 247

Gemini (Mercati), 254

Gluttony (Testard), 127

Goldbeater (Niccolò da Bologna), 201

Golden Legend, The (Jacobus de Voragine), 8, 205

Grandes chroniques de France, 146–47

Guillaume de Lorris Writing in His Studio (Acarie Master), 172

Hachette Psalter, The, 34, 141

Hares, 231

Harvesting, Pressing Grapes, and Libra (Master of B18), 259

Heavenly Vision, 85

Hell (Colombe), 267

Hellmouth (Master of Catherine of Cleves), 268

Hellmouth (Masters of Dirc van Delf), 266

Histoire de Jason, L' (Raoul Le Fèvre), 154–56

Holy Cross, The (Crivelli), 132

Holy Family (Master of Catherine of Cleves), 50

Hours of Anne de France, The, 29, 181, 267, 273, 275

Hours of Catherine of Cleves, The, 50, 100–105, 190–91, 232–33, 263, 268

Hours of Cecilia Gonzaga, The, 47, 51

Hours of Claude Molé, The, 236, 269, 276

Hours of Henry VIII, The, 45, 189, 213

Hours of Jean Robertet, The, 68

Hours of Marie de Rieux, The, 119

Hours of Pierre de Bosredont, The, 153, 272

Hugueniot, Guillaume, 153, 272

Hunters and Dogs Chasing Stag, 168

Hunt of the Unicorn Annunciation, 40

Incredulity of Thomas, 65

Ingeborg Psalter Workshop, The, 28

Jason Combating Corfus (Style of the Master of Champion des Dames), 154

Jason Leaving Oliferne (Style of the Master of Champion des Dames), 156

Jean de Vignay Translating the Text (Liédet), 8, 205

Jesus among the Doctors (Master of 1328), 52

Job on the Dungheap (Master of the Getty Epistles), 33

Joel Preaching to the Birds, 35

Journey of the Magi (Master of the Berthold Sacramentary), 20, 44

King and Queen Playing Chess (Masters of Dirc van Delf), 170

King as Protector of His Subjects, The, 142

King David and Musicians, 178

King Edmund as Alms-giver (Alexis Master and Workshop), 140

King Philippe V in Peace Conference (Master of the Cité des Dames), 147

King's Body as Allegory of the State, The, 144

Kiss of Judas, 57

Knight Being Armed for Foot Battle, A, 160

Knights of Rhodes under George de Bosredont Battle the Turks (Hugueniot), 153

Knights Tilt, Two (Bening), 162

Knight Templar Kissing a Cleric's Bum, 241

Lallement Missal, The, 60

Lancelot and the Magic Chessboard, 171

Lancelot Crossing a Sword-Bridge to Rescue Guinevere, 159

Lancelot Unhorsing Brandus, 158

Landscape (Clovio), 216–17

Landscape with St. Anthony (Master of Charles V), 214

Lapidation of St. Stephen (Perhtolt), 94

Last Judgment (Master of Edward IV), 71

Last Rites, 117

Last Rites (Masters of Dirc van Delf), 115

Last Rites and Michael Weighing Soul, 116

Late Follower of the Master of the Munich Golden Legend, 108

Leo X Receives His Liturgical Shoes (Attavante degli Attavanti), 131

Liédet, Loyset, 8, 72, 73, 205

Life, Passion, and Miracles of St. Edmund, King and Martyr, 122, 140

Lion Addresses the Other Beasts, 221

Lions Breathe Life into Cubs, 206, 219

Livre de la chasse (Gaston Phébus), 167, 169, 186–88, 228–31

Livre des prouffis champestres et ruraux (Petrus Crescentius), 192–93

Livre du roy Modus et de la royne Racio (Henri de Ferières), 168

Lodi Cathedral Antiphonary, 63

Lot's Wife Turned to Pillar of Salt and Destruction of Sodom, 31

Lovers in the Fields, 212

Luna in Exaltation; Taurus, 252

Lust (Testard), 129

Madonna of the Apocalypse, The (Master of the Berry Apocalypse), 76

Maius, 79, 82–84

Making Snares and Feeding Dogs, 187

Man Applying Medicine to His Teeth, 194

Manna, Emblem of the Sacred Eucharist, and Three Other Treatises, 215

Man Playing the Organ and David with Sling, 175

Marmion, Simon, follower of, 121

Marriage of King Philippe I and Queen Berthe (Master of the Cité des Dames), 146

Martyrdom of St. Erasmus (Master of Catherine of Cleves), 100

Mass of St. Gregory, The, 107

Mass of St. Gregory (Follower of Simon Marmion), 121

Master of B18 (Second Master of the Choirbook of San Domenico, Bologna), 256–59

Master of Catherine of Cleves, 50, 100–105, 190–91, 232–33, 263, 268

Master of Charles V, 214

Master of Edward IV, 71

Master of Guillebert de Mets, 133

Master of Isabelle di Chiaromonte, 251, 253

Master of Margaret of York, 192, 193

Master of Marguerite d'Orléans, 119

Master of Morgan 453, 38–39

Master of Petrarch's Triumphs, 236, 269, 303

Master of the Berry Apocalypse, 76–77

Master of the Berry Apocalypse Workshop, 152

Master of the Berthold Sacramentary, 20, 44, 95, 264

Master of the Bruges Chronicle of Flanders?, 157

Master of the Cité des Dames, 146–47

Master of the Getty Epistles, 33, 163

Master of the Moral Treatises, 74–75

Master of the Older Prayer Book of Maximilian I, 111

Master of 1328, 52, 120

Masters of Dirc van Delf, 114–15, 170, 266

Masters of Zweder van Culemborg, 99

Meal before the Hunt, 167

Meeting of Solomon and Sheba (Clovio), 32

Men Adoring Beast with Two Horns (Liédet), 73

Mercati?, Venturino, 254–55

Michelino da Besozzo, 98

Miniatures of the Life of Christ, 49, 57

Miniatures of the Life of Christ and Blessed Gerardo da Villamagna, 58–59, 64

Mocking of Christ (Pacino da Bonaguida), 58

Mostyn Gospels, The, 90

Mother Nature Forging Children (Acarie Master), 200

Mountain Goats, 225

Mounted Knight in Jousting Costume, A, 164

Nativity and Annunciation to Shepherds, 42

New Jerusalem (Maius), 82

Niccolò da Bologna, 62, 201

Nimrod Building the Tower of Babel, 183

Old Testament Miniatures, 26–27, 136, 150

Olivetan Master, 53

On Famous Women (Boccaccio), 202–4

Ordinances of Armoury and Miscellaneous Texts, 160–61

Ostriches, 227

Pacino da Bonaguida, 58–59, 64

Peacock Offered to Aristé, 166

Pentecost, 70

Perhtolt, Custos, 66, 94

Peri Holds the Sun on a Composite Lion (Sun in Leo), 249

Phaenomena (Aratus), 251, 253

Plague of Locusts, The (Master of the Moral Treatises), 114

Planisphere with Constellations (Master of Isabelle di Chiaromonte), 251

Plowing and Sowing (Bening), 196

Poyet, Jean, 37, 45, 60, 189, 213

Prayer Book of Anne de Bretagne, The, 37

Preparatio ad Missam Pontificalem, 131

Pride (Testard), 123

Priest Elevates the Host; Rabbit and Fox Carry Dogs (Style of Master Bertram of Minden), 243

Psalter and Book of Hours of Henry Beauchamp, Duke of Warwick, The, 178

Psalter and Book of Hours of Yolande de Soissons, The, 48, 67, 86, 110, 175

Quarriers Preparing Stone Blocks, 182

Rāgamālā series (Désākha Rāginī), 177

Raising of Lazarus (Clovio), 55

Read Albums, The, 165, 173

Régime du corps (Aldobrandino da Siena), 194

Registrum brevium, 158

Renner, Der (Hugo von Trimberg), 185, 221

Resurrection (Francesco da Castello), 63

Resurrection of Lazarus (Bening), 54

Return from Egypt, 51

Revelations (St. Bridget), 85, 130

Roasting Spitted Fowl (Master of Catherine of Cleves), 190

Roman de Lancelot du Lac, Le, 158–59, 164, 171

Roman de la rose (Guillaume de Lorris and Jean de Meun), 148, 172, 176, 182, 200, 212

Sagittarius (Mercati), 255

St. Agatha (Master of Catherine of Cleves), 102–3

St. Anthony (Masters of Zweder van Culemborg), 99

St. Barbara (Master of the Older Prayer Book of Maximilien I), 111

St. Bartholomew Baptizing King Polemius and His Family; His Arrest, Flaying, and Entombment, 92–93

St. Bridget Receiving a Book with Two Confessors, Who, Below, Present It to a King, 130

St. Domenic Receives the Rosary from the Virgin, 135

St. Fabian and St. Sebastian (Master of Catherine of Cleves), 101

St. John the Evangelist, 90

St. John Writing the Apocalypse (Liédet), 72

St. Lawrence on the Grill (Master of the Berthold Sacramentary), 95

St. Luke with Head of Ox, 234

St. Mark, 91

St. Martin Dividing His Cloak, 98

St. Mary Magdalen (Bening), 112

St. Michael Battling Demons

(Master of Catherine of Cleves), 104–5

*St. Veronica*, 106

*Satan and the Damned in Hell* (Master of Petrarch's Triumphs), 236, 269

*Saul Destroys Nahash and the Ammonites; Samuel Anoints Saul; Peace Offerings Sacrificed*, 136, 150

*Scribe Girard Acarie Presents His Book to King Francis I, The* (Acarie Master), 148

*Serpentarius on Scorpio* (Master of Isabelle di Charomonte), 253

*Shearing Sheep* (Bening), 197

*Simurgh*, 226

*Sirens*, 244

*Sir John Astley (left) Jousting*, 161

*Slaughtering a Pig* (Bening), 199

*Slaughter of the Innocents*, 48

*Sloth* (Testard), 128

*Snaring Rabbits with Bells and Nets*, 186

*Sphaera mundi* (Sacrobosco), 250

*Spotted Doe and Deer*, 224

*Spring Pastorale* (Master of the Getty Epistles), 163

*Strawberry Hours, The*, 118

*Strolling in the Countryside* (Poyet), 213

Style of Habīb-Allāh Mashhadī, 173

Style of Master Bertram of Minden, 243

Style of Muhammad 'Alī ibn Malik Husain, 165

Style of the Master of Champion des Dames, 154–56

*Table of Christian Faith, The* (Dirc van Delf), 114–15, 170, 266

Testard, Robinet, 123–29

*Theseus and Ariadne with Demon*, 265

*Three Marys at the Tomb* (Pacino da Bonaguida), 64

*Threshing and Leo* (Master of B18), 258

*Timarete Painting a Portrait of Diana* (Follower of the Bedford Master), 202

*Tower Scriptorium of San Salvador de Tábara*, 184

*Tracking a Scent*, 169

*Translation of the Body of Edmund* (Alexis Master and Workshop), 122

*Tree Planting and Grafting* (Master of Margaret of York), 192

*Triumph of Death, The* (Master of Petrarch's Triumphs), 276

*Triumph of Death* (Clovio), 277

Trubert, Georges, 274

*Two Foxes*, 222

*Universal Chronicle*, 30–31, 183

*Van Damme Hours, The*, 112–13

*Virgin and Child among Virgins* (David), 69

*Virgo Lactans*, 46

Visconti-Sforza Tarot Cards, 260–61

*Vision of St. Bernard* (Bening), 113

*Vision of the Lamb* (Maius), 83

*Vision of the Son of Man and the Seven Candlesticks* (Master of the Berry Apocalypse), 77

*Visitation*, 36

*Vita Christi* (Ludolphus de Saxonia), 71

*Voeux du paon* (Jacques de Longuyon), 166, 241

*Watchdogs*, 229

*Wheel of Fortune* (Bembo or Zavattari), 260

*Wild Boars*, 230

*Wild Woman Rescuing Child from Dragon* (Elsner), 245

*Wine-treaders*, 189

*Woman Milking a Cow* (Master of Catherine of Cleves), 191

*Woman Receives Wings and Her Flight; Pursuit of the Dragon*, 81

*Work in the Forests and Fields* (Master of Margaret of York), 193

*Worksop Bestiary, The*, 206, 218–19, 244

*Worshipping the Beast*, 80

*Yolande de Soissons Praying*, 86, 110

*Youth Putting on Falconer's Glove* (Style of Habīb-Allāh Mashhadī), 173

Zavattari, Francesco, 260–61

*Zodiac and Planets Circling Earth*, 250

Editor: Jeffrey Golick
Designer: Kevin Callahan
Cover Designer: Celia Fuller
Production Editor: Owen Dugan
Production Manager: Lou Bilka
Library Photographer: David A. Loggie

First edition

15  14  13  12  11  10  9  8  7  6  5  4  3  2

*Library of Congress Cataloging-in-Publication Data*
Pierpont Morgan Library.
    Illuminated manuscripts : treasures from the Pierpont Morgan Library / foreword by Charles E. Pierce, Jr. : text by William M. Voelkle and Susan L'Engle.
        p.  cm.
    "A tiny folio."
    Includes index.
    ISBN 0-7892-0216-6
    1. Bible—Illustrations. 2. Illumination of books and manuscripts, Medieval. 3. Illumination of books and manuscripts, Renaissance. 4. Illumination of books and manuscripts—New York (State)—New York. 5. Pierpont Morgan Library. I. Voelkle, William M. II. L'Engle, Susan. III. Title.
ND3355.P54  1998
745.6'7'0747471—dc20
                                                96-43628

SELECTED **TINY FOLIOS**™ FROM ABBEVILLE PRESS

- **American Art of the 20th Century: Treasures of the Whitney Museum of American Art** 0-7892-0263-8 • $11.95
- **American Impressionism** 0-7892-0612-9 • $11.95
- **Paul Cézanne** 0-7892-0124-0 • $11.95
- **Edgar Degas** 0-7892-0201-8 • $11.95
- **The Great Book of French Impressionism** 0-7892-0405-3 • $11.95
- **Treasures of British Art: Tate Gallery** 0-7892-0541-6 • $11.95
- **Treasures of Folk Art** 1-55859-560-0 • $11.95
- **Treasures of Impressionism and Post-Impressionism: National Gallery of Art** 0-7892-0491-6 • $11.95
- **Treasures of the Hermitage** 0-7892-0104-6 • $11.95
- **Treasures of the Louvre** 0-7892-0406-1 • $11.95
- **Treasures of the Musée d'Orsay** 0-7892-0408-8 • $11.95
- **Treasures of the Musée Picasso** 0-7892-0576-9 • $11.95
- **Treasures of the Museum of Fine Arts, Boston** 0-7892-0506-8 • $11.95
- **Treasures of the National Gallery, London** 0-7892-0482-7 • $11.95
- **Treasures of the National Museum of the American Indian** 0-7892-0105-4 • $11.95
- **Treasures of 19th- and 20th-Century Painting: The Art Institute of Chicago** 0-7892-0402-9 • $11.95
- **Treasures of the Prado** 0-7892-0490-8 • $11.95
- **Treasures of the Uffizi** 0-7892-0575-0 • $11.95
- **Women Artists: The National Museum of Women in the Arts** 0-7892-0411-8 • $11.95